ECLIPSE
OVER CLEMSON

The day Tigertown will never forget

EDITED BY **JIM MELVIN**
WITH **PETE MARTIN**

CLEMSON
UNIVERSITY
PRESS

Racing The Moon by Don Connolly. © 2005 Don Connolly, Sydenham, Ontario, Canada.
All rights reserved. Concept by Bob Morris. Research and composition by Don Connolly
and Bob Morris. Coronal shape from Wendy Carlos's image of the 1973 eclipse. Corona
orientation and "bead" location calculated by Fred Espenak, NASA. Connolly's painting—
depicting Concorde 001 emerging from umbral darkness at 12:07 GMT, June 30, 1973,
flying at 2,206 kilometers per hour at 17,602 meters above Niger at east longitude 14.38°
and north latitude 16.19°, north of Lake Chad—won first prize in the Commercial Aviation
category of the American Association of Aviation Artists 2005 competition, cosponsored by
Aviation Week & Space Technology.

ISBN 978-1-942954-52-1

Published by Clemson University Press in Clemson, South Carolina

Designed by Richard Jividen

This book is set in Trade Gothic and was printed by Ingram/Lightning Source.

To order copies, contact Clemson University Press at 801 Strode Tower, Clemson South
Carolina, 29634 or order via our website: www.clemson.edu/press.

CONTENTS

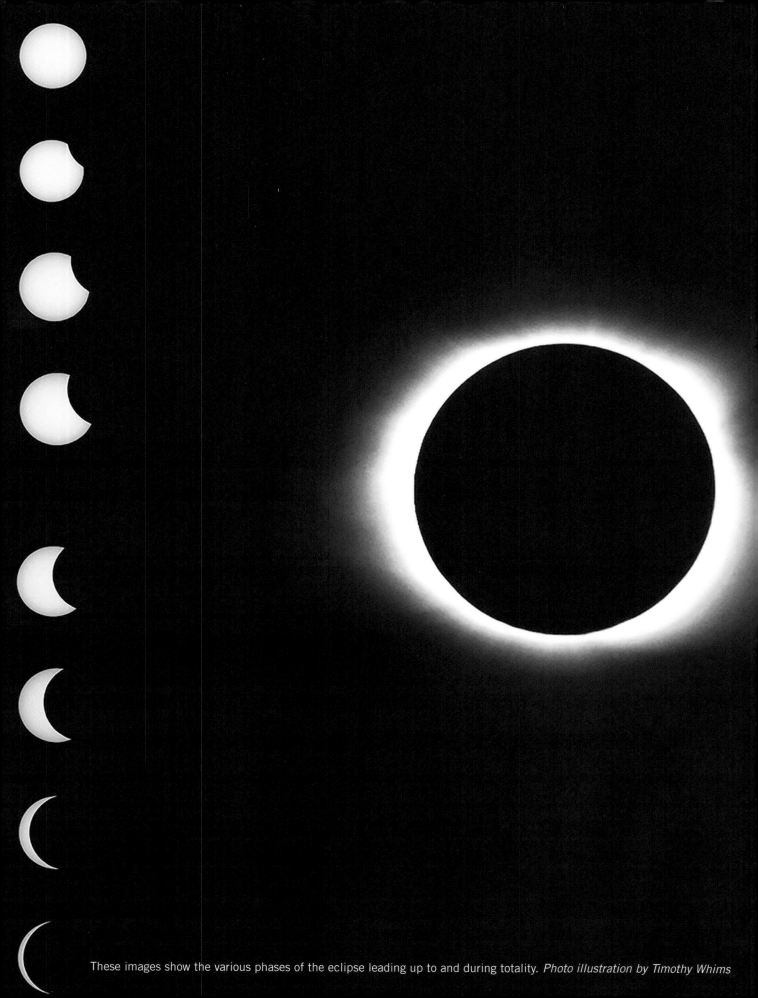

These images show the various phases of the eclipse leading up to and during totality. *Photo illustration by Timothy Whims*

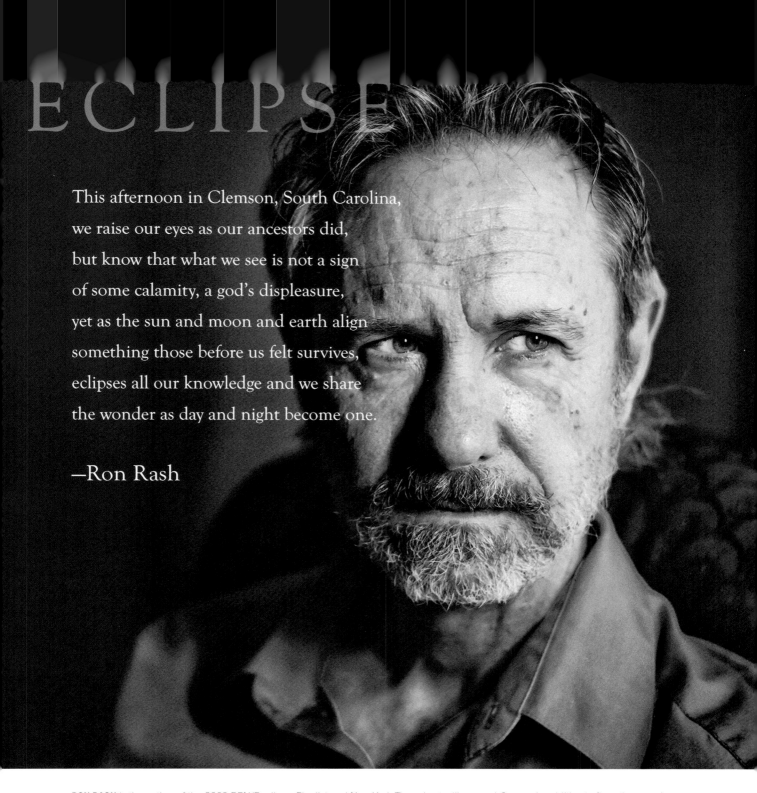

ECLIPSE

This afternoon in Clemson, South Carolina,
we raise our eyes as our ancestors did,
but know that what we see is not a sign
of some calamity, a god's displeasure,
yet as the sun and moon and earth align
something those before us felt survives,
eclipses all our knowledge and we share
the wonder as day and night become one.

—Ron Rash

RON RASH is the author of the 2009 PEN/Faulkner Finalist and New York Times bestselling novel *Serena*, in addition to five other novels, including *One Foot in Eden*, *Saints at the River*, *The World Made Straight*, and *Above the Waterfall*. He has published five collections of poems and six collections of stories, among them *Burning Bright*, which won the 2010 Frank O'Connor International Short Story Award; *Chemistry and Other Stories*, which was a finalist for the 2007 PEN / Faulkner Award; and most recently, *Something Rich and Strange*. Twice the recipient of the O. Henry Prize, he teaches at Western Carolina University.

ECLIPSE OVER CLEMSON

The day Tigertown will never forget

On August 21, 2017, a total solar eclipse raced across the United States from coast to coast. The path of totality began in the Pacific Ocean before first touching land just north of Newport, Oregon. For the next ninety-three minutes or so, it moved across the contiguous United States, finally passing over Charleston, South Carolina and fading away somewhere over the Atlantic Ocean.

Clemson University, located almost dead center within the path of totality, turned out to be one of the most popular places in the nation to view this eclipse. About 50,000 people came to campus that day to witness the rare celestial event. In addition, more than twenty-five local, national, and international media outlets were also in attendance.

At Clemson the eclipse started at 1:07 p.m. EDT. Totality began at 2:37 p.m. and lasted, coincidentally, two minutes and thirty-seven seconds. The eclipse ended at 4:02 p.m. It was hot and humid, but the sky was mostly clear throughout the day—and it was crystal clear during totality, producing one of the most spectacular views seen anywhere by anyone.

As a public service, Clemson University's College of Science made "Eclipse Over Clemson" a free event. Even the parking was free, as were the tens of thousands of solar shades we handed out. The goodwill this helped create was priceless.

People cheered. People chanted. People cried. I believe it is accurate to say that most of our guests will never forget it. Hence, the title of our book …

Eclipse Over Clemson chronicles one of the most extraordinary days in Clemson University's storied history. It even includes a poem—written specifically for this book—by renowned southern author Ron Rash. And you'll find more than a hundred full-color images of the eclipse and the crowd, taken by a team of talented photographers. I hope you enjoy this book as much as we enjoyed producing it.

One final thing: The next total solar eclipse will occur on July 2, 2019 and will cross over a huge swath of the Pacific Ocean before sweeping over parts of Chile and Argentina. See you there!

—Jim Melvin, College of Science

MESSAGE FROM THE DEAN

DR. CYNTHIA YOUNG
COLLEGE OF SCIENCE

Space has always captivated our minds. From the Apollo missions to the Challenger explosion to the moon landing, people have always found fascination and commonality in space. In 1969, nearly 600 million people worldwide watched as Neil Armstrong stepped onto the surface of the moon and uttered those famous words, "That's one small step for man, one giant leap for mankind." That same sense of awe and wonderment was revived on August 21, 2017 when the sky opened up just in time for the perfect view of the total solar eclipse.

The eclipse was viewed by an estimated eighty-eight percent of American adults, which represents 215 million people. This level of public interest in a scientific event is unprecedented and worth celebrating. People drove hundreds of miles to Clemson University to catch a two-minute-and-thirty-seven-second view of the cosmic phenomenon. We welcomed about 50,000 stargazers to campus, all with the hopes of catching the perfect view of the eclipse. Clemson had the unique opportunity to be the only top twenty-five university with an R1 designation in the path of totality. Our faculty, staff, and partners at the College of Science put in hundreds of hours to ensure that everyone in attendance would have a memory worth reliving for years to come.

Eclipse Over Clemson chronicles our piece of the nationally shared experience, and explores the efforts behind the amazing eclipse celebration. You will read personal accounts of the day from our scientists, naturalists, psychologists, media relations experts, and even novelists. Their stories are echoed in the beautiful images from professional photographers and photo contest winners.

Since the eclipse, the College of Science at Clemson has received hundreds of letters, emails, and phone calls thanking the university for its efforts to make science available to the public. In fact, the community participated in outreach programs prior to the eclipse and has been invaluable in collecting data since. When discovery, learning, and engagement intersect in citizen science, it is powerful. The value of this cannot be overstated. It shows that Clemson's science is both locally relevant and globally impactful.

Thank you to all who contributed to our celebration, and to all who attended. This extraordinary day was made even more magical because we witnessed it together on our beloved campus.

College of Science director of communications Jim Melvin joined Clemson University's eclipse-planning team in February 2017. *Photo by Ken Scar*

THE JOURNEY TO TOTALITY
JIM MELVIN
DIRECTOR OF COMMUNICATIONS, COLLEGE OF SCIENCE

On August 21, tens of thousands attended a free mega-viewing party at Clemson University to experience the 2017 total solar eclipse. And though the event went off without a hitch, the lengthy planning process was an adventure in itself.

FOR ME, THE JOURNEY TO TOTALITY BEGAN NOT AT 1:07 P.M. ON August 21, but more than seven months before, when I accepted the position of communications director for Clemson University's College of Science.

On a chilly day in the middle of February, media relations colleague Clinton Colmenares and I were discussing my new position. During the conversation with Clinton, he mentioned something about a total solar eclipse that would occur in late August.

Embarrassingly, it was the first time I had even heard of it.

But it certainly wouldn't be the last. In the coming months, I would learn more about this eclipse than I could have ever imagined, and it would consume my life like the moon consuming the sun.

Before joining the media relations department at Clemson University, I had been a lifelong journalist, including stints at the *St. Petersburg Times* (now known as the *Tampa Bay Times*), the

Greenville News and the *Charlotte Observer*.

Having finally had my fill of journalism, I was thrilled to join Clemson University in January 2015 as a media-relations specialist for Public Service and Agriculture and the College of Agriculture, Forestry and Life Sciences. I later became a member of the College of Science in February 2017.

The rest, as they say, is history.

THE START OF SOMETHING BIG

I can't remember the first time I met Dr. Amber Porter, a lecturer in the Department of Physics and Astronomy. But I do remember her telling me that she had been named the director of our eclipse event and had been working on it for more than a year. Being the new guy trying to ingratiate himself to any and all, I promised her that I would provide assistance in any way I could.

Little did I know what I was signing on for. But since it was still only February, I wasn't overly concerned about what might lie

2

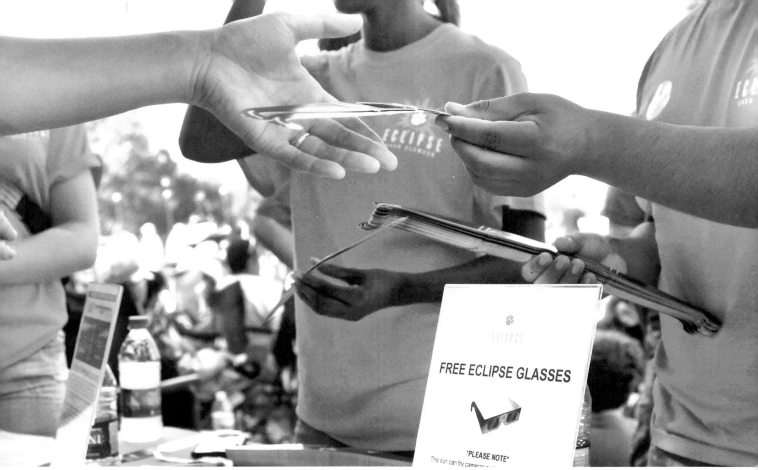

Clemson University gave out tens of thousands of solar glasses for free on Eclipse Day. *Photo by Bill Serne*

ahead. Time was on our side.

Or was it? The eclipse over Clemson would begin at 1:07 p.m. on August 21, 2017, no matter what. It's not like we could postpone the event to a future date if we weren't quite ready.

The cosmic clock was ticking.

When I reflect now on all the things that occurred between February and Eclipse Day, one of the first things I remember was Amber saying to me that she had run into some logistical issues that were causing her to lean toward holding a small event on campus—maybe a few thousand people or less—rather than a larger one. I'll go into more detail on a few of those issues later in this story, as will Amber in her chapter in this book. But early on, at least, the more I thought about it, the more I began to see stars. The College of Science, in its current incarnation, was formed in July 2016. This rare and extraordinary opportunity to spotlight the new college and its already long-established astrophysicists seemed too juicy to pass up.

We at Clemson are a proud bunch for many reasons. One of them is that our Tigers are the 2016 defending national champions in college football. Riffing off this, I began proclaiming to anyone who would listen that an on-campus, mega-viewing event of the total solar eclipse would be the College of Science's national championship. It was our chance to shine—figuratively and literally—before the state, nation, and world.

And so, the arduous process of organizing a free event that would eventually draw 50,000 people—along with an astounding conglomeration of state, national, and international media—took on a new burst of steam.

LET'S HOLD A MEETING—*OR FIFTY!*

How do you get things done at major institutions of learning? The same way you do at other large public and private operations.

With meetings.

We started with small gatherings, then medium-sized ones, then large ones. We discussed parking, security, medical needs, vendors, venues, lights, cameras, action! You get the picture.

There were so many things to consider and so many variables. For instance, unlike one of our football games, we weren't certain of crowd size. It could be as small as 1,000 or as large as 100,000, which meant we had to devise plans that could accommodate either end of the scale.

To say the least, this wasn't easy.

One of the main obstacles faced by our ever-expanding event team was that our sun, moon, and Earth had not chosen a convenient day, at least from our university's perspective, to form the perfect eclipse alignment. The first day of classes for the fall semester was August 23, and the calendar for the week leading up to that day was already filled with a slew of complex and hectic activities. In fact, Eclipse Day, August 21, would have been one of the busiest and most crowded days on campus all year even without the eclipse. Just clearing a window from 1–4 p.m. took several weeks of planning. We owe the team of Dr. John Griffin, Associate Provost and Dean of Undergraduate Studies, many thanks.

It was that crazy. And that challenging.

To be honest, there were times when it seemed next to impossible. Clemson University is stocked with talented leaders,

faculty, staff, and students—but even this plethora of riches was being tested to its limits. We were all working hard, but we had a monster on our hands. And I admit that I was feeling a bit guilty about it. I felt like a Dr. Frankenstein who had unleashed terror on the masses.

In the end, though, things began to slowly but surely fall into place. Mike Nebesky, Clemson University's director of procurement and business services, came through big time by hiring Flourish Events, a professional events coordinator based in Greenville. Jamie Prince, Briana Carr, Peyton Lewis, and the rest of the Flourish Events staff helped Amber and me with tasks that a scientist and communications director are ill-equipped to handle, like renting tents, setting up stages, ordering portable lavatories, inviting food trucks, and countless other details.

Amber and I received further assistance from a man named Rick Brown, who is a well-known member of the "eclipse-chaser community." Rick, a veteran of fifteen total solar eclipses, had chosen Clemson University to be his sixteenth. He traveled from his home in Long Island to visit us several times and offered his advice, free of charge. He would end up playing a pivotal role on Eclipse Day. But more on that later, too.

On one occasion, Rick, Amber, and I toured campus in search of the best venue to hold our main event. One of our favorite locations was the dike alongside Lake Hartwell that is adjacent to our athletic facilities and within view of Memorial Stadium. But we later found out that the dike is owned by the US Army Corps of Engineers, and we were eventually denied permission to use it as our home base, for safety reasons. It was disappointing, but there was nothing we could do.

We now needed to come up with a Plan B.

A few days after learning that we could not use the dike, I pondered our predicament while taking an exercise walk in the interior of our campus one evening. Each step I took brought me no closer to a solution. However, near the end of my walk I passed in front of our Watt Family Innovation Center, a state-of-the-art facility that is one of the most extraordinary buildings on campus. The Watt has an expansive grass field in front of it called the South Campus Green, which is also adjacent to our R. M. Cooper Library. Suddenly, it dawned on me: This is the place. And as it turned out, Plan B worked beautifully.

There are many reasons why. The Watt Center's staff, led by Dr. Todd Marek, Dr. Barbara Speziale, Tullen Burns, Tim Howard, Mark Jensen, Susan Reeves, and a host of others, embraced the eclipse event with energy and enthusiasm. Teri Alexander, Rhonda Blurton, and the Cooper Library staff also worked tirelessly on our behalf.

In addition, Dr. Mark Leising, an accomplished astrophysicist who was then the interim dean of the College of Science, made certain that any nearby building and outdoor lights would be turned off during totality. Most importantly, Mark inspired the university to join together in support of the event.

Believe me when I say that none of this was simple. Without Mark, "Eclipse Over Clemson" would have faded into obscurity.

As Eclipse Day approached, our team overcame one potential complication after another. The list grew smaller and smaller … until there were no complications left.

CLEMSON UNIVERSITY BECOMES A MEDIA MAGNET

As Eclipse Day approached, my days on the job grew ever more frenetic. I began to literally fear my Clemson University email account. I would begin each day with about fifty eclipse-related emails, gulp down some coffee, and then start to answer them, one by one. I would get on a roll and reduce fifty to thirty. But then my office landline phone would ring with an eclipse-related question—perhaps a request from a superior, or even a member of the general public asking for something as simple as directions to campus—and by the time I had finished with each call, I would turn back to my computer and see that I now had fifty-five emails. Yikes! But as they say, it is what it is, so I would start churning through them again and eventually reduce the number to twenty. But then my cell phone would ring and … well, you get the picture. This went on literally nonstop from about 8:30 a.m. to 7 p.m. every weekday. And even sometimes on weekends.

Early in the eclipse-planning process, Heidi Williams and Matt Bundrick of Clemson University's Creative Services department put together an "Eclipse Over Clemson" webpage, with an associated blog that Amber and I used to post information and updates. Pete Martin, a new member of the College of Science communications staff, took over from there, updating existing materials and adding new items on a continuous basis. Pete amended one of our most important elements—our events calendar—more than twenty times. He also designed a variety of attractive online and print components for public and media consumption. Meanwhile, Hannah Halusker, a young and extremely talented science writer on my staff, wrote story after story about our eclipse plans and outreach efforts. Though it was a complex endeavor, the "Eclipse Over Clemson" webpage eventually became a thing of beauty. I know this because many of the calls and emails I received on an almost daily basis came from local, national, and even international media outlets who had discovered us via our webpage and had chosen to make Clemson University their home base for the first US coast-to-coast solar eclipse in a hundred years.

With prodigious assistance from Wanda Johnson-Stokes, another media relations colleague, and the aforementioned Clinton Colmenares, our eclipse team began to assemble a cadre of media as impressive as our university had ever seen. Among those who came to our campus during the weeks leading to the eclipse and, most importantly, on Eclipse Day were the *Washington Post*, the *Wall Street Journal*, National Public Radio, the BBC, The Weather Channel, and national crews from NBC,

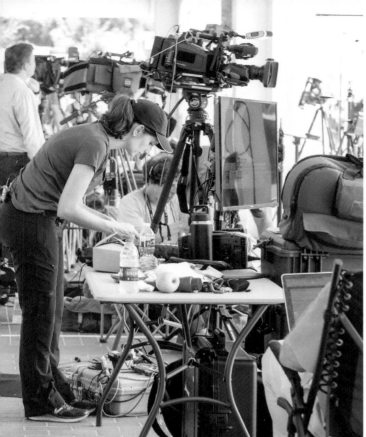
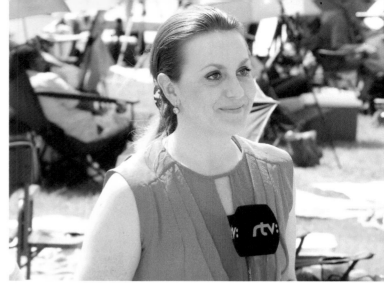

CLOCKWISE FROM TOP LEFT: The Weather Channel on-air meteorologist Maria LaRosa and a cadre of other media turned an exterior floor of the Cooper Library into a tangle of cables, cameras and microphones. *Photo by Ashley Jones*; Alena Taranova, a correspondent for "Radio and Television Slovakia," represented one of more than 25 local, national and international media outlets that covered the event. *Photo by Pete Martin*; Clemson's pre-eclipse planetarium shows were packed throughout the morning. *Photo by Craig Mahaffey*

ABC, and FOX. Plus, virtually every local broadcast affiliate and newspaper sent crews to Clemson.

On July 21, one month from the big day, NBC News arrived on campus to do a series of preview segments about our upcoming eclipse event. I met the NBC team outside the Watt Center at 3 a.m. The building's more than 200-foot-long outdoor display monitor was lit up in full glory, creating a blazing backdrop to NBC's coverage, which ended up reaching more than 200 affiliates nationwide. While the rest of us sweated profusely and swatted at mosquitoes in the humid pre-dawn heat, on-air talent Erika Edwards performed in front of the camera for hours and yet somehow managed to look as fresh at 10 a.m. as she had seven hours before. I never once saw even a single bead of sweat on her brow. I asked her how she managed it. Her simple answer: "This is what I do for a living."

Which brings up another point: Either in person, on the phone, or by email, I ended up conversing with more than fifty on-air personalities, producers, and camera operators from more than two dozen local, national, and international media outlets. And every single person, without exception, was good natured, respectful, and humble. So, if there is a perception that the media are a bunch of wolves looking for blood, I beg to differ. I was amazed by how nice they were. Some of them even became my friends.

AT THE MERCY OF MOTHER NATURE

Many of us have acquired some sort of compulsive behavior over the course of our lives. I developed a new one: obsessively checking long-term weather forecasts. Though we were successfully putting the final touches on our event, we remained at the mercy of Mother Nature. A stormy, rain-filled day would ruin our event. An overcast day would diminish it. A relatively clear day with an untimely cloud at totality would sadden a lot of hearts (including mine).

I began to tell a running joke about how I had purchased a tiny hut in the wilds of Alaska; and that if we ended up with poor weather on Eclipse Day, I planned to spend the rest of my life curled on the floor of the hut in a fetal position. This joke wasn't particularly funny, but it did seem to make people become a bit nervous around me. I wasn't sure if this was because they were worried that I was going crazy, or if it was because they too had purchased huts. If the latter is true, then there's a rich Alaskan real estate agent out there somewhere.

The home page of The Weather Channel (TWC) became my main point of reference. I checked Clemson's long-range weather forecast in the morning, the mid-morning, before lunch, during lunch, after lunch, early afternoon, mid-afternoon, late afternoon, before dinner, during dinner, after dinner, later in the evening, before I went to bed, and even when I got up in

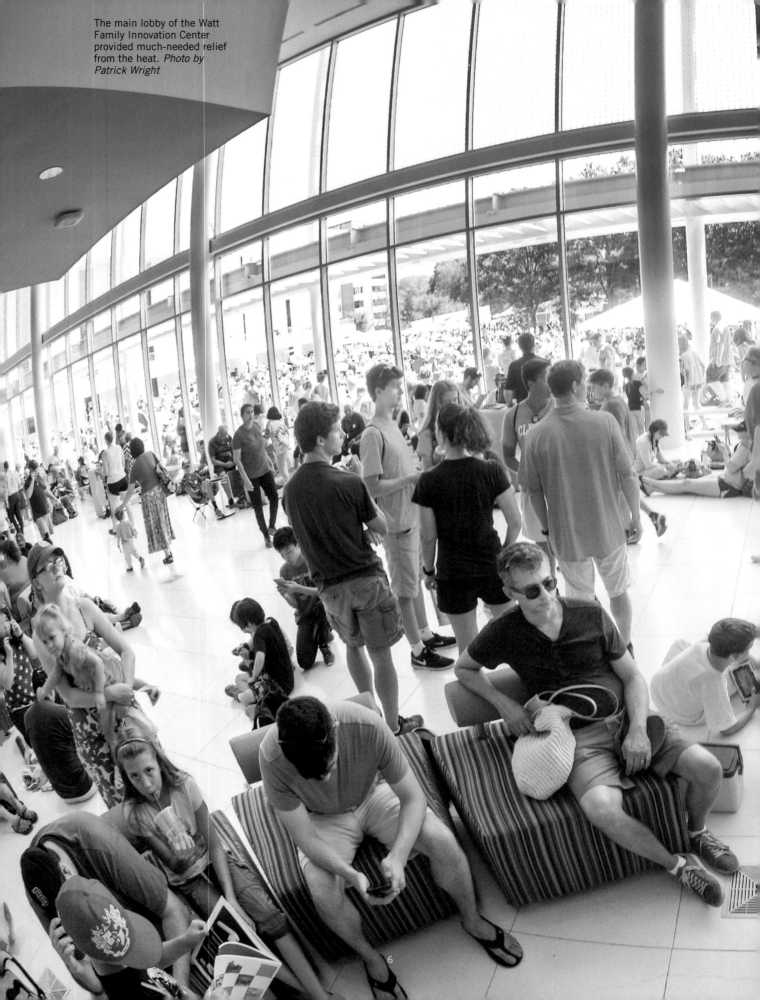

The main lobby of the Watt Family Innovation Center provided much-needed relief from the heat. *Photo by Patrick Wright*

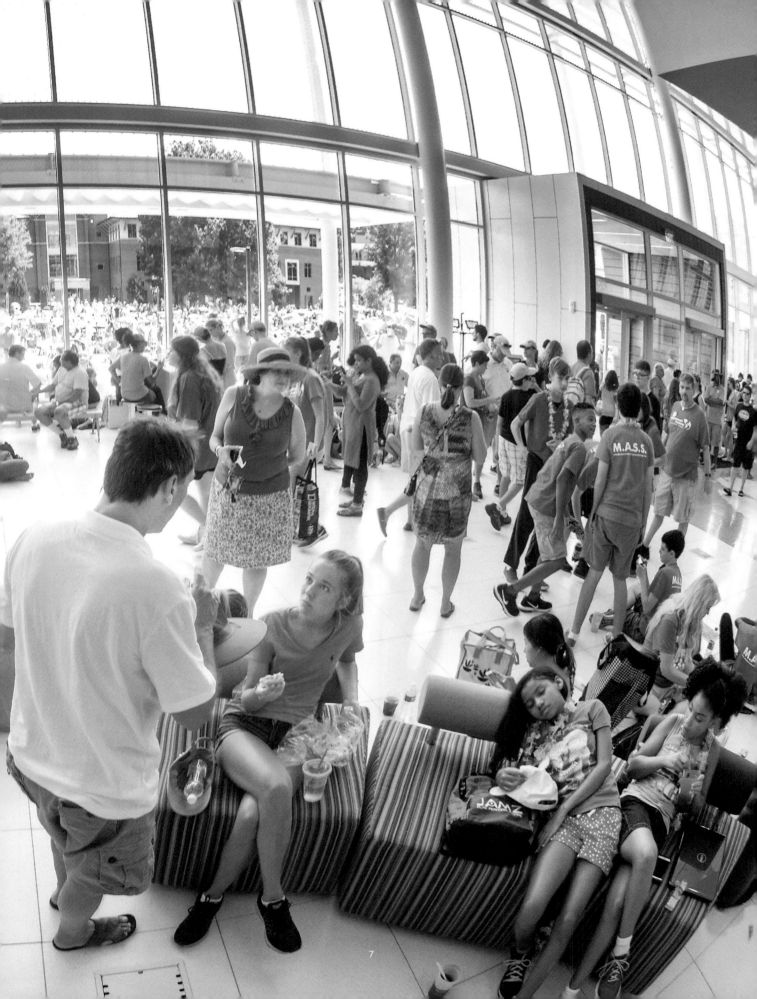

the middle of the night to use the bathroom. The site's ten-day forecast, which is really a fifteen-day forecast, became my best friend and worst enemy. One day, TWC would predict clear skies over Clemson with only a ten percent chance of rain on August 21. Another day: partly cloudy, thirty percent chance. Then: cloudy, sixty percent chance. Back and forth. Round and round. Up and down. The forecast changed not just by the day, but by the hour. The word "rain" became my most hated four-letter word, followed by an almost equally dreaded six-letter word: "cloudy." The only word I grew to cherish contained five letters: "clear."

I would sit on my backyard deck after work and whisper the word in mantra-like fashion: clear, clear, … c-l-e-a-r.

My wife Jeanne, who observed my obsession in person, sometimes chided me. As I would tumble into a trance, my eyes distant and unfocused, she would say: "You're thinking about the eclipse, aren't you?"

My answer was always a rather sheepish, "yes."

Between the two of us, these frequent trances became known as "The Glazed Eclipse Look."

On August 19, two days out, TWC's Clemson forecast called for clear skies and virtually no chance of rain. Did I dare hope for the best?

No. When it came to the weather, I trusted nothing and no one. I'm a "believe-it-when-I-see-it" kind of guy—to the nth degree.

THE FINAL THREE DAYS

Eclipse Day was a Monday, but the Saturday and Sunday before were quite busy for me. On Saturday, I met with two members of The Weather Channel team—on-air meteorologist Maria LaRosa and producer Mike Bogad—and gave them a tour of our campus. On Sunday, I arranged for the BBC's Haley Thomas and Nikki Verrico to interview several of our scientists.

All told, our Clemson experts held dozens of interviews with media leading up to the eclipse. And on Eclipse Day, they would do dozens more. Rick Brown, our eclipse-chasing personality, became a media darling, conducting twenty-plus interviews himself—and doing so with an impressive blend of showmanship and eloquence.

Clemson became the place to be. I doubt that any other location in the United States had as much media coverage as our event drew. It was extraordinary, as well as being a lot of fun. As a media-relations specialist, our "Eclipse Over Clemson" mega-viewing party became the highlight of my career. I can't imagine that I will ever approach the likes of it again.

As I said earlier, the cosmic clock was ticking. Whenever I had access to my laptop, even as late in the game as August 19–20, I checked TWC's August 21 forecast. I even asked Maria what she thought, and she predicted clear skies. Hearing this directly from a professional meteorologist was, for me, like a form

of psychological counseling. I finally allowed my ultra-skeptical mind to tilt toward optimism. It appeared extremely likely that we would have no rain and mostly clear skies. Our only remaining danger was the potential of a fat, fluffy cloud making an untimely overhead appearance at 2:37 p.m. My fingers were crossed as tightly as twisted iron cables.

Heedless of any of this, the cosmic clock ticked down to 5 a.m. Monday, August 21. When I showed up on campus, it was dark but already bustling with activity. Ready or not, Eclipse Day had come.

But the good news was, we were ready.

My Eclipse Day began with a flurry of activity. I was peppered with questions and requests from our eclipse team and also from the media, who had rolled onto our campus en masse over the weekend and had positioned themselves on the bottom two floors of our library adjacent to the Watt Center. About twenty-five media outlets were there from all over the state, nation, and world, and they had transformed the library's breezeways into a complex tangle of cables, cameras, and microphones.

Meanwhile, our public guests from off-campus were being directed to a series of remote parking lots that officially opened at 8 a.m. But as early as 7 a.m., more than 100 people had already gathered at our main venue. I looked up at the sky and saw nary a cloud. It was early, certainly, but now it was just a matter of time. Which would come first? The eclipse or a cloud? And also, I wondered—for the final time—how many people would show up? A thousand? Or a hundred thousand? I was about to find out.

By 8 a.m., a steady stream of guests was pouring into campus—people of all ages, shapes, and sizes. This was gratifying, to say the least. I was also pleased to see that our guests appeared to be ethnically diverse. Science has proven over and over that it has the power to unite us. On August 21 on the campus of Clemson, science proved it again.

To say that the next several hours passed in a blur would be the grandest understatement of my life. As the crowd swelled to about 50,000—which would be our final, official estimate—it became almost impossible for me to walk more than ten feet in any direction without someone stopping me. I was wearing a Clemson-orange shirt and a straw hat adorned with a tiger paw. I also had a "STAFF" lanyard around my neck and my official "College of Science: Director of Communications" magnetic badge attached above my shirt pocket. In other words, I was hard to miss. It seemed everyone wanted a piece of me, which was flattering but also a bit overwhelming. The next thing I knew, 8 a.m. had morphed into 10:45 a.m., when our main stage show was scheduled to begin.

The show was emceed by Wanda Johnson-Stokes and Dr. Jeremy King, who played off each other like a pair of seasoned celebrities. It boasted a lineup of speakers that included Clemson astrophysicists Dr. Amber Porter and Dr. Mark Leising, eclipse expert Rick Brown, Clemson conservationist Dr. Rob Baldwin,

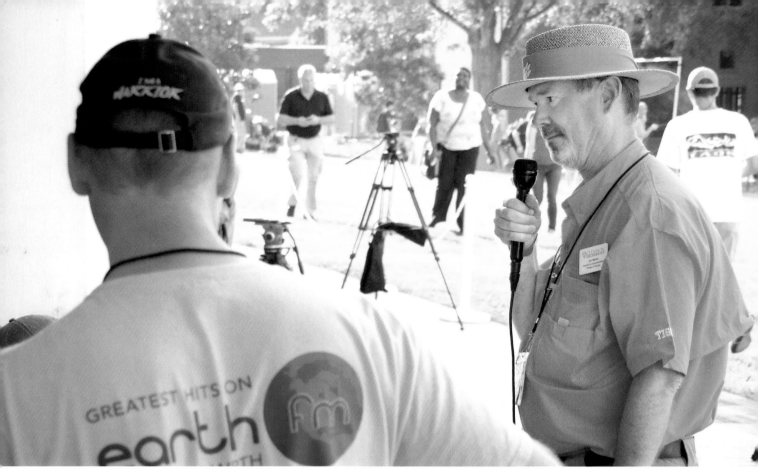

Melvin conducted an interview with Upstate South Carolina radio station Earth FM WRTH during the eclipse, one of many interviews with local and national media that day. *Photo by Pete Martin*

and me. By the time I had finished speaking, it was nearing 1 p.m.

I looked at the sky. For the most part, it was still clear. Except … a few rather large clouds could be seen on the southeastern horizon, giving rise to a primitive desire in me to rush to my laptop and check TWC's hourly forecast once again.

Somehow, I resisted.

The day, which had started out warm even in the early morning, had now become hot and muggy. Now that our stage show was over, I could sense that some of the people in the crowd were feeling sluggish and a bit moody. Though the eclipse had not even begun, many in attendance had already been sweltering in the summer heat for hours. They needed some sort of additional boost. And at 1:07 p.m., the boost arrived, in the form of the first sliver of darkness across the sun.

Cheers arose—followed by a collective explosion of good-natured energy. The long-awaited total solar eclipse over Clemson was underway.

For me, it was a joy and a relief. We had entered the final mile of the marathon.

THE MAGIC OF TOTALITY

Between answering a thousand questions, fulfilling a thousand requests, and sneaking off once to the bathroom, I managed to put on my solar shades about a dozen times and watch the eclipse's progression. It was fascinating and beautiful, but no

more so than I had expected. Then again, this was my first total solar eclipse, so I didn't really know what to expect. All I did know was that every person I had previously spoken to who had seen a total solar eclipse had told me—with identical passion— that totality would be a life-altering experience. But hearing this secondhand and experiencing it firsthand would be two entirely different experiences.

I was ready for the real thing.

Around 1:30 p.m., the southeastern band of clouds I mentioned earlier began to ominously expand. At one point, around 1:45 p.m., a patch of clouds actually covered the sun. Was it possible that after months of preparation, totality would be degraded in the final minutes? As it turned out, the exact opposite happened. The clouds blew away, as if swept apart by a pair of giant hands. Now, there was nothing but a safe, comforting blue.

At 1:55 p.m., Clemson's nationally recognized Tiger Band, led by Dr. Mark Spede, gathered on the rooftop of the Strom Thurmond Institute. Our president, Dr. Jim Clements, stepped onto the stage at 2 p.m. and gave a rousing speech to the crowd, which included a shoutout to me and several others for our roles in helping organize the event. I shook his hand afterward and thanked our university's highest-profile personality for his graciousness. This was yet another career high in a day seemingly filled with them.

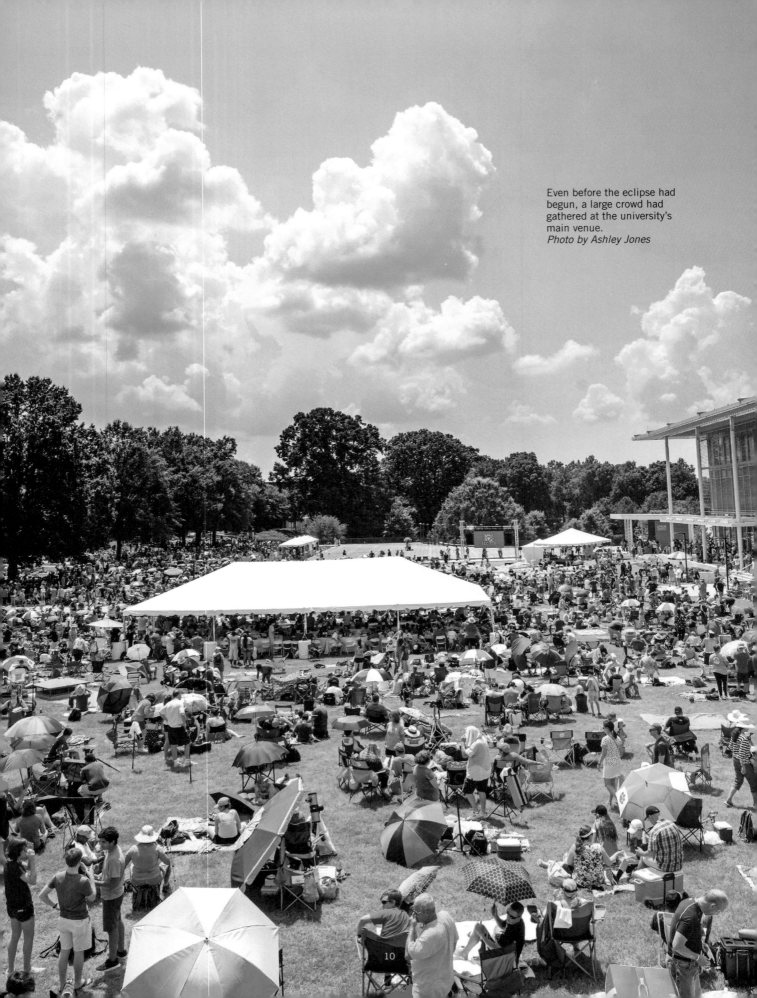

Even before the eclipse had begun, a large crowd had gathered at the university's main venue.
Photo by Ashley Jones

10

My wife and my youngest daughter, Lia, were at the event. The crowd had become so dense, it was nearly impossible to move from one place to another. But I managed to weave this way and that, juking between sweaty bodies like a running back evading tacklers. At about 2:25 p.m., I found them. I looked at my wife and smiled. She nodded back. All the long hours, all the evenings and weekends I had spent at my computer, all the "Glazed Eclipse Looks" she had endured for months were about to pay stupendous dividends.

Rick Brown took the mic and talked us through what happened next, saying just enough to enhance the experience without getting in the way. His impromptu performance won the hearts of the crowd.

With surprising suddenness, the quality of the light changed. Colors became peculiarly flat. The wind picked up. The temperature dropped. Sporadic shouts and cries broke the otherwise mesmerized silence. Rick pointed out that the planet Venus had become visible on the western horizon. We all looked skyward and cheered.

It was 2:32, 2:33. It grew ever darker. The emotional energy emitting from the massive gathering filled the air like luscious smoke.

2:34 … 2:35 … 2:36.

The excitement became a tangible thing, as infectious as joy.

It grew darker and darker.

Then … it was 2:37. Totality arrived. The moon covered the sun, except for its now-brilliant corona. We took off our solar shades and stared at the transcendent phenomenon.

The crowd erupted. I was later told by several people that the cacophony of screams, shouts, cheers, chants, and sobs was heard many miles from campus. Meanwhile, I was stricken by a deluge of emotions. My jaw started to quiver and tears sprang from my eyes. Everything I had accomplished to this point paled in comparison to what I was now privileged to behold. Totality was everything I had hoped for and tenfold beyond. For two minutes and thirty-seven seconds, I stood with my wife, daughter, and 50,000 others and wept in wonder.

When totality ended, the darkness dissipated surprisingly fast. I felt a bit embarrassed, like the way you do when you cry at the end of a movie and then the lights come on and the rest of the audience can see that your eyes are bloodshot and that tears are streaking your face. But a part of me wasn't embarrassed, because I saw many others who appeared to have cried as well.

I spent the rest of the eclipse being congratulated by more people than I could count. I guess that having been recognized by President Clements on stage had turned me into a temporary celebrity—sort of a fifteen-minutes-of-fame kind of thing. Most of the people who came over to me were strangers, yet they said the kindest and most genuine things. Amber Porter and I locked eyes a couple of times. We both knew what we had been through, and we both knew that this particular movie had a happy ending.

THE AFTERMATH

Soon after the completion of totality, the crowd began to disperse. By 4:02 p.m., when the eclipse officially ended, I would guess that fewer than a thousand of our guests remained. But some did linger well into the evening, as if savoring the final tidbits of one of the best meals they had ever eaten.

I remained on campus for several more hours, chatting with members of our eclipse team, doing several more interviews with media, and helping to tidy up here and there.

At one point, a fancily dressed gentleman with a cane approached me and asked where he could find a shuttle to take him to his car. I told him where to wait, but when I passed by him about fifteen minutes later, he was still sitting there in the heat. Too much had gone right for me to bear seeing something go wrong. So, I grabbed the keys to one of our golf carts and gave him a ride to his car, which was parked about a mile away. We had a nice chat, and he thanked me for the personal escort. I told him that I was honored to oblige.

I left campus at 8 p.m., a full fifteen hours after I had first arrived. When I pulled into my driveway, I discovered that my wife, who had returned home long before me, had taped a flurry of hand-printed signs onto one of our garage doors. "You are AMAZING!" "JUST … WOW!" Sweet things like that. I sat there in silence and smiled and smiled.

When I finally got out of my car, it began to rain.

JIM MELVIN became director of communications for the College of Science at Clemson University in February 2017. Melvin joined Clemson in January 2015 as a media specialist for Public Service and Agriculture and the College of Agriculture, Forestry and Life Sciences. During his first year at Clemson, he won a gold medal in the national Association of Communications Excellence (ACE) contest in the category "Writing for the Web." In 2016, he won another gold medal in the ACE contest in "Writing for a Magazine" and a silver medal in "Writing for the Web." Earlier in his career, Melvin totaled more than thirty national and state awards as a journalist for the *Tampa Bay Times*, *Charlotte Observer*, and *Greenville News*. He is also a novelist whose work includes *The Death Wizard Chronicles*, a magical, six-book epic fantasy for adult audiences.

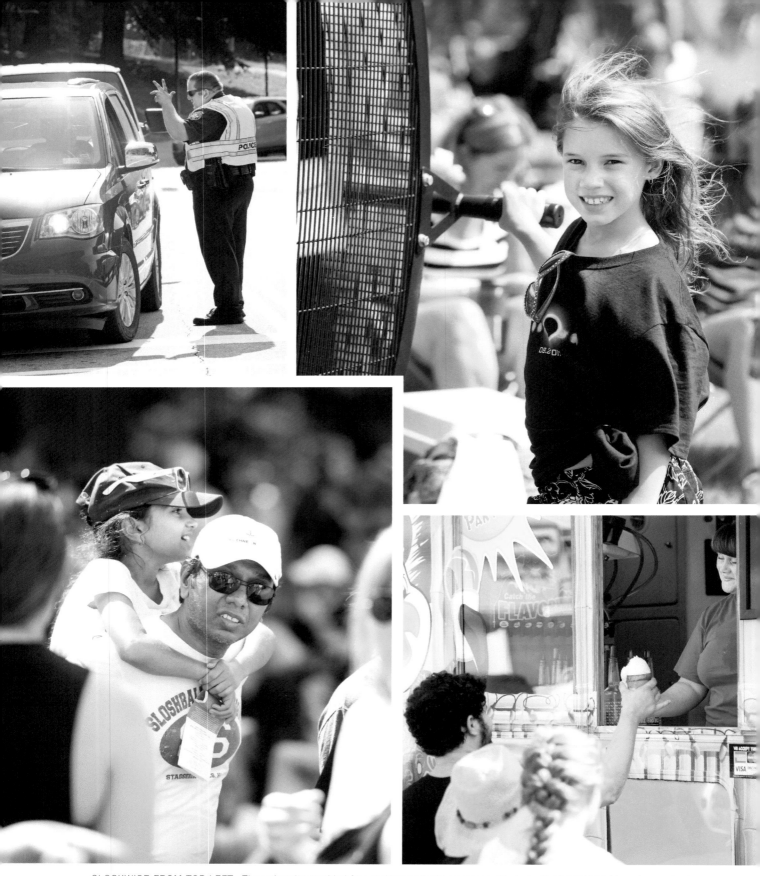

CLOCKWISE FROM TOP LEFT: The university provided free parking and other services. *Photo by Patrick Wright;* Huge fans helped keep visitors cool during the hot, humid morning and afternoon. *Photo by Craig Mahaffey;* Food trucks provided tasty treats for hungry and thirsty attendees. *Photo by Craig Mahaffey;* A diverse crowd of about 50,000 attended the event. *Photo by Craig Mahaffey*

Eclipse-chaser Rick Brown (right) gave valuable advice to Amber Porter and the Clemson eclipse team leading up to and during the eclipse. *Photo by Pete Martin*

A DAY TO REMEMBER WAS YEARS IN THE MAKING

DR. AMBER PORTER
LECTURER, DEPARTMENT OF PHYSICS AND ASTRONOMY

Clemson University's eclipse planning began several years before August 21, 2017, but the mega-viewing party came fully to life during the final hectic months.

MY JOURNEY TO WATCHING THE TOTAL SOLAR ECLIPSE BEGAN several years ago when I was a graduate student in the Department of Physics and Astronomy at Clemson University. Not long after I began giving shows in the department's newly renovated planetarium, I realized how much I loved engaging with the public through astronomy, and so I sought out several opportunities for increasing my capacity as a science communicator.

After I completed a science communication workshop in 2014, I was appointed as the first Astronomy Ambassador in South Carolina by the American Astronomical Society. To retain this title, I have to plan or participate in at least three astronomy education events each year. My Ph.D. advisor at the time, Dr. Mark Leising, mentioned that the total solar eclipse was approaching and that it would great if I could begin preparing activities for how the department could celebrate the big event. Keep in mind that this was three years in advance of the actual

event; and unfortunately at the time, I knew little about eclipses other than that the celestial bodies align perfectly. Much to my later dismay, I didn't immediately grasp how big this celestial event would be, and I quickly forgot about making plans.

Fast forward to August 2016, when I graduated with my Ph.D. and joined the physics and astronomy faculty as a lecturer. After confirming with my astrophysics colleagues that we had not set any eclipse plans into motion, I pulled together an ad hoc committee of professors, lecturers, and our interim department chair to brainstorm what should be included in the perfect eclipse party. Our ideal day included educational stations with planetarium shows, hands-on demonstrations, performing arts shows, and booths providing safety information. Many of these original plans were later incorporated into the actual "Eclipse Over Clemson" event.

After the department's preliminary meeting, I met with Mark, who was then serving as Interim Dean of the College of

Leading up to the eclipse, physics and astronomy graduate student Andrew Garmon collaborated with Amber Porter on more than 20 different outreach events around Upstate South Carolina. *Photo by Jim Melvin*

Science, so that we could determine the best viewing location on campus and also how to ask for permission to use the space. Any open field with clear views of the horizon is a great spot for observing an eclipse, and Clemson has a variety of spaces that fit this description. We had to begin to think seriously about the number of people who might be attracted to our event. Mark advised me not to get my hopes up and that maybe only 500 people would watch the eclipse with us on August 21, since our previous attempts at hosting large astronomy events were not as well attended as we had expected. I was hoping for a crowd closer to 2,000, so we decided on several options that could be considered "overflow" spaces if the crowd exceeded 500.

Even with Mark's help, my next few months of eclipse planning involved sending out cold-call-style emails to various administrative departments across campus to try to describe this once-in-a-lifetime event known as a total solar eclipse.

By the time the new year rolled around, I began to focus on how we could use the eclipse to educate our local community more generally about astronomy and science as a whole. I was inspired by astronomy educators from around the country who had converged in St. Louis in December 2016 for the "Engage Every Child in the 2017 Solar Eclipse" meeting, hosted by the Astronomical Society of the Pacific. I heard amazing stories about educators who began STEM (Science, Technology, Engineering, and Mathematics) programs in their diverse communities for inner-city kids and in Hispanic neighborhoods, and were thus able to engage underserved communities in

conversations about science and the upcoming solar eclipse well in advance of the event. Programs of this caliber are not easy to produce, so I started small by introducing short eclipse videos into planetarium shows and focusing my eclipse lectures for my astronomy students on the "can't miss" moments of the upcoming total solar eclipse.

Our eclipse-planning luck finally turned around in February 2017, when John Wareham, assistant director of the Rutland Institute for Ethics, arranged for the "Eclipse Across America Awareness Tour" to visit Clemson University. In addition, John met with local media and was able to lure Chris Justus of WYFF-4 to broadcast live outside Clemson's Brackett Hall in the hours before the on-campus public forum.

John also contacted Jim Melvin, the newly hired director of communications of the College of Science, and this is when the ball really started rolling again. Jim immediately recognized the potential impact that a large event for the total solar eclipse could have on the still-forming College of Science. Less than a week after the public forum, Jim arranged a live phone interview for me with RFD-TV, and we began to put Clemson on the map as a premier location for viewing the total solar eclipse in August.

With Jim's persistent help and his connections with all of the various media outlets at Clemson University, we slowly got the word out that a huge celestial event would be taking place over Clemson, and that it truly was worth celebrating. In April 2017, we received the great news at a Convocation steering committee

Dr. Amber Porter provided an on-stage overview of the event before the eclipse began. *Photo by Pete Martin*

meeting that the university would try not to host any events between 1–4 p.m. on August 21 so that everyone on campus, especially the incoming freshmen, would be free to watch the solar eclipse unfold. With this news came the reality that the "Eclipse Over Clemson" event might need to host—in addition to any outside guests—about 20,000 Clemson staff, faculty, and students, who would already be on campus on Eclipse Day for reasons totally unrelated to the eclipse. It quickly became obvious to Jim and me that a public information director and a scientist were inadequately equipped to handle the logistical issues of an event of this size and scope, nor did we have the time to fill out all the forms, attend all the meetings, and place all the orders that go along with large-scale event planning, especially if we were to be also required to perform the duties of our "real" jobs.

Our stress levels were slightly reduced near the end of May when Clemson University signed an event-planning contract with Flourish Events, a marketing agency based in Greenville, South Carolina. In theory, Jim and I were then able to concentrate on what we do best—writing stories and teaching astronomy—while Flourish Events handled the logistical details. But truthfully, we still had a long road ahead and time was quickly running out. With each passing week, we chipped away at deciding how many eclipse glasses to buy, securing an open venue on campus, struggling to raise money so that we could provide the event to the public free of charge, and feeling secure that the dim skies of totality would not be washed out by emergency lighting on sidewalks and in buildings surrounding the event space. It was hard work, but we were determined that the "Eclipse Over Clemson" event would be perfect.

And as it finally turned out, perfect it was.

OUTREACH MANIA

By August 21, the Department of Physics and Astronomy had participated in more than twenty different outreach events around upstate South Carolina. Our first large event was "Space Day" on March 11, 2017 at the Roper Mountain Science Center in Greenville. About 300 parents and children wandered through our exhibit each hour to make chalk art solar coronas and learn about the invisible ultraviolet light put out by the sun with UV-changing pony bead bracelets. We also crafted tabletop comets out of dry ice and separated white light into the rainbow of colors with diffraction glasses. The warm response of the families to our hands-on approach toward eclipse education encouraged us to pack our calendar with educational events.

Whenever the weather and the solar activity cooperated, we set up our department telescopes with solar filters on the front lawn of the Kinard Laboratory of Physics to encourage passersby to look at sunspots. Those who stopped to chat were amazed to learn that sunspots are cooler regions on the sun's surface, and although they might look like freckles on the sun, the spots are typically as large as planet Earth. We also had a few eclipse

glasses for people to gaze through, and this helped get them excited about the upcoming solar eclipse.

After the university let out for the summer, we hosted "Solar Saturday" at the Central-Clemson Regional Branch Library to introduce the total solar eclipse to local Pickens County families with eclipse crafts and sunspot gazing. I co-organized this event with physics graduate student Andrew Garmon, who led the children through the crafts while I operated the telescope. By the end of "Solar Saturday," Andrew and I were asked by at least three parents who were also local teachers if we were available to visit the local schools to teach them about eclipses.

Andrew and I started by visiting Anderson County schools in the final week of their academic year, and we continued reaching out to local youth all the way until the Friday before the eclipse, when we held our last school-related eclipse event at R.C. Edwards Middle School in Central, South Carolina. Andrew and I created an educational slideshow that began with how eclipses were viewed throughout history and then eventually progressed to how eclipses occur and how to look at the sun safely with eclipse glasses. At first, Andrew and I were nervous about how to keep children engaged during an assembly (rather than arts-and-crafts) environment. However, we asked for volunteers from the audience to help us demonstrate the immense distance needed between the sun and the moon for the moon to appear to be the same size as the much larger sun. Andrew's ego also wasn't hurt too much when the audience laughed at him as he tried on one pair of sunglasses, then two pairs of sunglasses, followed by an oversized clown pair of glasses in order to help kids come to the conclusion that eclipse glasses are the only glasses safe enough to look directly at the sun without damaging their eyes.

Throughout the summer, we used some flavor of this presentation to talk about the eclipse with families at library events, staff and administrators at university development and eclipse-planning events, and college students at back-to-school bashes. Each event that I participated in was an honor and a pleasure, and I have amazing memories that I won't soon forget. Some of my favorites are the number of kids who had learned the importance of using eclipse glasses but who wondered if their dogs needed eclipse glasses too. (The answer is no, pets do not need glasses, but it is a cute photo opportunity.) I also enjoyed when kids made the connection, without prompting, about whether it would be safe to video the eclipse with smartphones. Andrew told them a story about his roommate who pointed his iPhone 7 in video mode toward the sun for twenty seconds on a normal spring day and could only take pictures in shades of blue from then on because the sun had damaged the camera optics.

I also remember the exciting change of pace after talking about the eclipse with the Happy Hearts Club of Seneca and also one of the retirement communities at Clemson Downs, just days after completing eclipse activities with three- and four-year-olds

at the Clemson Childcare Development Center. There was the sheer exhaustion after Andrew and I drove between the towns of Pickens, Central, and Liberty to do three back-to-back library events in one afternoon. Still, it was all worth it. The eclipse allowed me to meet and interact with so many people in the local community, and I am so grateful for all those experiences.

THE WONDERS OF ECLIPSE DAY

Eclipse Day was a magical day for me. One year of planning and an intense six months of teaching classes, attending meetings, giving interviews, and holding outreach events passed by in an exciting blur. I had planned on being at our "Eclipse Over Clemson" event around 7 a.m. on August 21, but I had numerous loose ends to tie up, including getting all of the right materials to outreach booths and writing my introductory speech that would officially kick off the event at 10:45 a.m. When I finally walked outside my office that morning, I had a hard time getting to the event space because I kept running into so many people along the way who noticed my "VIP" badge and needed directions somewhere or who just wanted to talk about how excited they were to be on campus. As I made my way toward the South Campus Green, I was giddy at how many people I saw camping out on the lawn. "Build it and they will come" from the movie *Field of Dreams* sprang to mind. At that time, I had no clue how many more people would flock to our event in the hours leading up to totality.

First contact occurred at 1:07 p.m. in Clemson. The morning passed quickly as I ran back and forth from the main stage to catch the various speeches to the outreach booths at the amphitheater to see whether everything was running smoothly, and to check on our distribution of eclipse glasses. I was standing in line at the frozen lemonade stand when I heard someone yell out, "It's starting!" I glanced up with my eclipse glasses like everyone else in the vicinity and could just barely make out that a smudge of the sun had disappeared on the right limb. "Interesting," I thought. The initial partial phase of the eclipse seemed to pass by slowly as I glanced up every now and then. I had been showing pictures of the eclipse sequence for months on end and describing how the moon appears to slowly take bites out of the sun. Based on what I had heard and read on the Internet, the partial phases were nothing compared to totality. But I found the slowly diminishing crescent sun and the blackest of black moon to be breathtaking and beautiful—and being able to see this in person moved me.

As I made my way back to the South Campus Green to find my spot for totality, I was overwhelmed by the number of people I saw. Some parts of the lawn were baking in the sun, but people filled even those areas. Shady spots under large trees hid the sun from view, but portions of the crowd also gathered there. People swarmed on the outside steps of the Watt Family Innovation Center and on every open spot around our "Eclipse

Over Clemson" venue. The crowd that day was later estimated to be about 50,000 visitors, which is just what we were hoping for—not too many, not too few.

As totality approached, I could feel a buzz in the air from everyone's enthusiasm. The light turned unusually dim, shadows grew sharp enough that I could see fly-away hairs on the top of my shadow's head, and the small piece of horizon that I could glimpse between buildings and the tops of people's heads slowly turned lovely shades of pink and orange. It seemed that we were waiting patiently and, at the same time, impatiently, for the moon to completely engulf the sun's surface. The crescent sun grew smaller and smaller until my vision in the eclipse glasses went black. I then shouted "take off your glasses," so that no one in my vicinity would miss the corona.

The corona was a unique and diffuse pearl-white color with thick spikes of coronal material coming from the equator, since the sun was in a less-active part of its cycle. One of the most magical things about seeing a total solar eclipse in person is that no photograph or video is able to capture how the human eye perceives the shimmering crown. Videos often show a blob around the dark new moon and good photographs tend to show too much detail. Throughout the two minutes and thirty-seven seconds of totality, I looked frantically between the sunset horizon, the few birds I saw flying overhead, Mars and Venus shining in the daytime sky, and the sea of people all looking up and pointing in wonder.

In what felt like ten seconds, totality was over and we all scrambled to put our eclipse glasses back on as the diamond ring appeared, signaling the end of the total phase. With the main show over, most of our crowd of 50,000 people packed up and started moving out. While those people unfortunately sat in traffic on Interstate 85, I enjoyed the end of the eclipse with a feeling of relief and ease. I had my picture taken with hundreds of partially eclipsed suns shining through tree leaves. I was also carrying around a small colander and can strainer to show those interested that it didn't matter that the colander had small round holes and the strainer had small square holes, the holes would only project the partially eclipsed sun on the ground. As I continued to engage with the people who were slowly wandering back to their cars, many asked to take a picture of the colander and the suns it projected while others gave their heartfelt thanks to Clemson University for putting together such a phenomenal event.

I might have been given the title "Lead Coordinator of Eclipse Over Clemson," but our event was spectacular because of everyone involved. The event would not have run as smoothly without the engaged citizens, supportive colleagues, Clemson's media relations teams, news teams from around the country, Clemson facilities staff, the fire, emergency services, and police forces, our Flourish Events planners, hundreds of volunteers, and our expert outreach coordinators. I'm glad we all shared this usually-once-in-a-lifetime chance to stand in the shadow of the moon together.

AMBER PORTER is a lecturer in the Department of Physics and Astronomy in the College of Science at Clemson University. She holds a Ph.D. in physics from Clemson University (2016), where she explored the three-dimensional shape of supernova explosions in distant galaxies. Porter continues to be interested in cosmic explosions, time-domain astrophysics, and the interstellar dust of other galaxies. Porter also serves as director of the Clemson University planetarium and oversees the astronomy laboratory courses. She is particularly interested in sharing her love of the cosmos with non-technical audiences, and discovering how the access and affordability of informal learning environments can increase the representation of diverse individuals in her field of study.

BEING IN THE MOMENT

HANNAH HALUSKER
PUBLIC INFORMATION COORDINATOR, COLLEGE OF SCIENCE

Onlookers at Clemson University relive their experiences at "Eclipse Over Clemson."

FROM THE OUTSIDE LOOKING IN, THINGS AT CLEMSON UNIVERSITY appeared to be business-as-usual on the morning of August 21, 2017. Graduate students were working in their offices, newly arrived freshmen were waking up in their high-rise dorms, and faculty were locking up their cars in employee green parking spaces to start their workday. But in the heart of campus, it looked more like a Saturday during football season than a Monday in the summertime.

From the South Campus Green beside the Watt Family Innovation Center, to the amphitheater beyond the Reflection Pond, and across the university at the Snow Family Outdoor Fitness and Wellness Center, tens of thousands of visitors came to campus to watch the total solar eclipse together. They traveled from near and far to a tree-filled campus in Upstate South Carolina, some seeking a university atmosphere, some wanting an organized and accommodating event, and others hoping to share in the experience with like-minded space enthusiasts.

Their reasons for attending aside, the 2:37 p.m. start of totality united a campus full of energized onlookers.

Traversing the crowd, it was easier to find someone from out of the state than it was to stumble upon a Clemson local. Hotels in the area were booked months in advance of August 21, reserved by families from Arizona to New York, and even from across the pond in London, Israel, and Italy. This was a once-in-a-lifetime moment, they said, and Clemson had been forecast to have one of the clearest views of the totally eclipsed sun.

For those in attendance at Clemson on August 21, the date will be burned in their memories for the rest of their lives. And the people who experienced that magical day firsthand were more than happy to talk about how they were affected by the cosmic phenomenon. Starting here and scattered throughout this book are some examples of what a diverse sampling of people had to say.

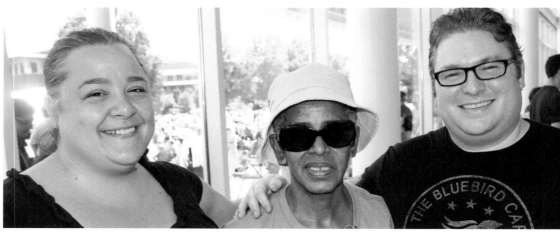

FROM LEFT: *"We flew down from Connecticut to Clemson, of course, because it's a university and it has proximity to the centerline of the total eclipse. This is a graduation present to my son, who wanted to see the eclipse, so we were trying to figure out where we were going to go. Once we decided that, we became quite enthusiastic about it, and we went out and bought glasses and goggles and a solar telescope, and adaptors for our iPhones to record the event. We've been planning since March."* —Bill Harris, Wilton, Connecticut.
● *"When we were searching for a place to watch the eclipse, Clemson was so open and welcoming to the community. We felt it would be a great eclipse experience to be here. For us, Mark said ninety-six percent coverage wouldn't do. We have to have one hundred percent. So we came here. We thank the school for being so kind and organized for the community."* —Lucy Sharpe (center), with Nichole Stearns and Mark Morley, Atlanta, Georgia

QUOTES FROM THE CROWD TAKE 1

CLOCKWISE FROM TOP LEFT: *"I came to Clemson for the eclipse because I saw on an app that it had 100 percent view here, and I just wanted to see it for the first time."* —Rohan Lidhar (far left), Cumming, Georgia; *"I came to Clemson to see the eclipse because I think it's cool. I've never seen one before. I expect to see a circle of bright light for two and a half minutes."* —Aryan Patel (second from right), Cumming, Georgia ● *"My entire family is from New Jersey, and we decided to come to Clemson for a couple reasons: One, you guys have the infrastructure to support all these people coming to see this eclipse. Also, I go to Michigan, so I wanted to see what another football school was like."* —Vignesh Jagathese, South River, New Jersey ● *"We're here for one of the best viewing areas of the eclipse in the whole country. We have a friend who went to Clemson, graduated in '83, so we also wanted to visit some good friends."* —Jim Stauffer (left), Odenton, Maryland; *"We saw a partial eclipse when we were very young, and we used a shoebox to protect our eyes. There was no such thing as eclipse glasses then, so we're very happy we have those now. We've studied a lot about the eclipse and we're so excited. We flew into Charlotte and drove from there down to here."* —Carol Goodart, Odenton, Maryland ● *"I wanted to come to a university setting to watch the eclipse. I checked the forecast this morning, and it said y'all were going to have better weather here in Clemson than anywhere else I could go to, so I drove from downtown Atlanta. This is my first time coming to your campus, and it's a beautiful campus."* —Corwin Robison, Atlanta, Georgia ● *"Our daughter graduated from Clemson four years ago, so we chose to come here to watch the eclipse. My youngest daughter is moving here, so we figured if she's moving, we might as well do it this weekend. We drove all of her stuff from California to here to make sure we could be here for the eclipse. We have friends from California who drove to Nova Scotia way back when to see the total eclipse and they're now driving to Oregon. I figured if they're going to do it twice, I've got to do it at least once."* —Pat Chambers (left), La Crescenta, California

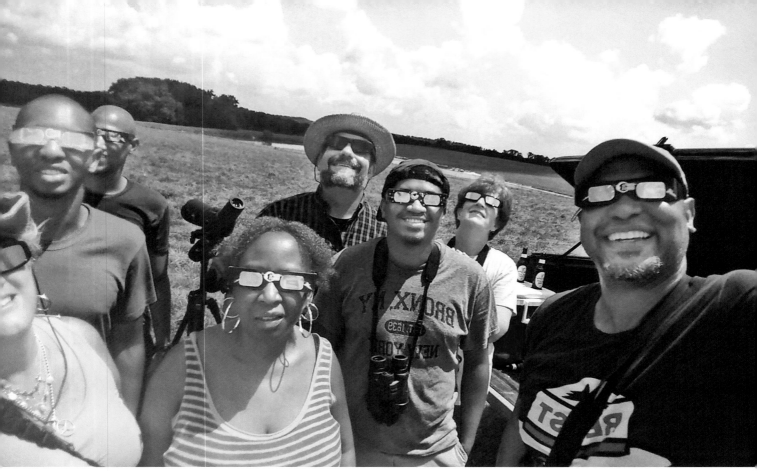

Dr. J. Drew Lanham (far right) gathered with family and friends in Townville, South Carolina. *Photo by J. Drew Lanham*

ALL GONE
DR. J. DREW LANHAM
PROFESSOR, DEPARTMENT OF FORESTRY AND ENVIRONMENTAL CONSERVATION

A mystic ornithologist's non-blinding stare into totality brings back memories of a different time and place.

THERE'S SOMETHING ABOUT THE IDEA OF "TOTALITY" THAT RINGS apocalyptically in my ears. Growing up "country" like I did under the tutelage of a grandmother whose daily machinations often involved Biblically inspired declarations of death and world-ending events like bloody moons, hooting owls, and yes, solar eclipses, the idea of everything being gone in one fell sweep of a divine decree (or anger spree) was something I came to expect. The God of Abraham regularly smote people, and even entire races and a planet, in various and sundry ways that had me on constant guard. My grandmother, Mamatha, came of age in the first half of the twentieth century; her underpinnings of Christianity were spiked with West African and Native American mysticism. For me, this meant reading to her from the Book of Revelation on an almost-nightly basis. I read aloud prophesies of "wars and rumors of wars." I also learned about weird things happening in the skies—things appearing, disappearing, ascending, and descending. And so, I looked up a lot as a kid, kind of expecting the skies to fall at any moment. It was like being a chocolate-skinned Chicken Little. When things didn't collapse on any

given day, as I'd been told they would, I could move my mind over to thinking about other kinder, gentler subjects. Foremost among them was looking up to see what birds might be flying through the soon-to-be falling sky. The fascination with flight first pulled me into the ornithological realm, but everything else about birds—the beauty of colorfully glowing feathers, other-worldly songs, their constant vigilance and talents to escape danger, and the miraculous magical abilities to travel great distances and stitch space and time together with their wings—made me do more than want to know about them. I wanted to be one of them. It was a daily mental commute between faith and fantasy, Chocolate Chicken Little and Little Brown Icarus; these identities have come full circle to make me whom I am today.

In that divided world of wondering when it would all end and the next moment when I might somehow be able to transform myself into some flying bird, I've become this hybrid mystic-scientist wondering about the real things we know that can "end" it all. As a conservationist, I'm steeped in morose persistent totalities—extinction, climate change, the population

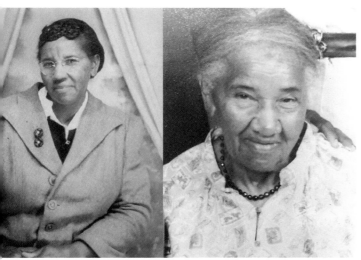

Lanham's grandmother, Mamatha, came of age in the first half of the twentieth century and maintained her spiritual underpinnings throughout her life. *Photos courtesy of J. Drew Lanham*

bomb, and habitat loss top the litany. They're all things that can bring it all crashing down (or surging up) around us. In a way, it's my grandmother's apocalyptic bemoaning of an apocalyptic quartet of horsemen and "God sending Noah the rainbow sign— said it won't be water but fire next time"—come to fruition. Climate change is the "fire" emanating from the very sun that I want to see fade into night just a bit after midday.

The cosmic event coming—Biblically and ecologically—is out of my hands. I accept this, but it can be a depressing thing to think about the disappearance of things forever, life being eclipsed by what we do as humans. And so, I work at trying to shortstop the manmade totalities that we can see coming. Today, though, as heaven darkens and totality finds the space I occupy, there's nothing I can do about it beyond watching. I can't do anything about the sun taking a siesta and casting the world into darkness before it's supposed to. And today, it's not something I want to change. In fact, the question for lots of us in this business is just that. What can we change? What should we change? How do we change the things we choose to alter? The sun might be a bit out of all our leagues, though. My grandmother would've been unfazed at the prospect of us not being in control. In all of her mystic musings, she gave full credit to her god. "He" was in control, was her mantra. "God rules and super rules," she'd say. And so, she carried that through the week and into Sundays, when she was willing to spend hours in a church praying, singing, and listening to some long-winded preacher validate the coming doom that would certainly come from the heavens. Her church flock was her confirmation. The totality of death meant a life in heaven; an eternity in paradise. If you were "good." Go the other way and there was, again, a fiery and torturous forever in hell, where there was weeping and teeth gnashing. That binary choice—good to heaven or bad to hell—was the simple law she lived by and expected me to, as well. Judgment Day was coming. She warned me of this, and the preacher and all the people sitting in those pews knew it.

Talk about a totality to fear; this was it. Death and destruction would be everywhere. People would be taken up into the sky or cast down into fiery chasms that yawned in the ground. Those were the lessons being taught, and in my ten-year-old head, it wasn't a hopeful set of images to behold. For me, way back then, I just wanted to be out somewhere looking for some bird, which flew above all the doom to come. Sitting in church, shoulder-to-shoulder with people consumed in all the bad to come, made me edgy and hopeless. Heaven seemed a long way off, and there were way too many non-fun hoops to jump through in order to get there. With adulthood and the relative freedom to choose my own spiritual (or non-spiritual) trajectory, field and forest became cathedral and temple; birds the ever-evident angels. I mostly choose to worship in a congregation of one. Whatever gods might exist are welcome to watch, but I leave control to adaptation, evolution, and the whims of weather, physics, and the conjuring of coincidence. That's who I've mostly been as a bird scientist—an ornithologist bent on seeing science as the scriptural text for understanding the things I see. As an ecologist, it's not about experimentation or "control." I have other things. I'm comfortable with mostly watching, wondering, recording, and sometimes analyzing the phenomena that unfold in front of me— birds weighing in at a few ounces migrating across hundreds of miles of water, beyond barriers human-made and natural—to find refuge in the same places they did the year before. This is miraculous to me. Sunsets, moonrises, frost-fall on autumn leaves—it's all inspiring, and I've not asked any deity to provide it. I think it's maybe because I was taught that what God would give, he would take away—and not in a nice way.

But today, I'm looking up and not thinking much about God or my dead grandmother. But there's still a bit of mysticism roiling about the whole coming-totality thing. And although I'm often alone in my birding pursuits, today seemed too big not to share. I've brought along a few friends—some who've traveled hundreds of miles to be here—and my family. The event has mushroomed into gigantic proportions across much of South Carolina, but I've decided to find a quieter spot for us to revel in heaven's darkening. The little Upstate farm community of Townville is a spot I visit regularly to find peace and birds. It's my little slice of heaven in the midst of so much that seems apocalyptic these days. Although not listed as a "place to be" for this event of a lifetime, it's close enough and not crowded. It's where I want to be and have invited a few others to share.

The sun is near its swelter-sweat inducing zenith. This time of day, most birds have the hard-wired sense to find shelter, pipe down, and chill out. It's late in the season too, and most species are done with rearing the next generation. The nesting is done and migration is already underway. Most of us out here are birders, and we set up scopes and begin peering through binoculars to see who's around. A kettle of turkey vultures circles off to the east. A misdemeanor of crows—maybe a half dozen or

For Lanham, one of the fascinating parts of the eclipse was watching the reaction of birds. *Photo by J. Drew Lanham*

so—feeds on waste seed by the cattle troughs but soon flies off silently. Down on the farm ponds, a few ducks—woodies, blue-winged teal, and a couple of motley mallards—dimple the water. Around the margins, there are shorebirds. Killdeer doing their usual name-calling. And a smattering of sandpipers—pectoral, least, and semi-palmated—skittering about and plying the mud for fuel before they continue southward journeys that will take some of them to the other end of the Earth. On an adjacent pond, juvenile blue herons and a great egret stand out starkly in bleached white plumage that throws the light back at us in a reflective brilliance. It almost always makes these lithe, rather small-bodied birds look larger than they are.

The pastures are empty. I'm thinking that the herds of Angus that are usually dotting the pseudo-Piedmont prairie at the Dobbins Cattle Company are likely on their way to becoming steaks and burgers. I'm not sure cows ever look up for divine inspiration, but whatever bovine gods look after the afterlives of cattle must have pretty full agendas. I'd counted on being able to record whether there was some sort of ruminant response to the event but then everything had probably gone dark for them already. Beyond the shorebirds and waterfowl at the ponds, there's not much song to record other than a grasshopper sparrow buzzing feebly somewhere down the fence line. Bird-wise, it's a typical mid-summer day's haze.

And so, here we all are. A congregation of bird-obsessed totality watchers looking up and wondering—waiting for the sky to besmudge itself. My grandmother would not have been out there with us. Besides the cold beers being guzzled against the

blazing heat, gathering like this to fete the disappearing sun would've been anathema. No, Mamatha would've been praying. She wouldn't have put on any special sun-gazing glasses to watch the event. She would've been inside, on her knees praying hard to her God for mercy and deliverance—and for the sun to come back. Her faith, and the positive result of the sun re-emerging the last time she heard of it disappearing from the sky in 1918, would've lead her to believe that prayer works. In 1918, Ethel Belle Jennings Lanham would've been almost twenty-five years old and waiting for her young doughboy husband, my grandfather Joseph Samuel Lanham, to return from another event of Totality—World War I. He'd been in the trenches, gassed, shelled, shot at, nearly starved, and stricken with God-knows-what diseases, and had seen any matter of horrors that would've led him to believe that his Totality would come at any moment. Beyond the sun "over there" being constantly clouded by the literal fog of war, I imagine that the sight of any sliver of sun was a rare thing for him. His reality was survival, and the eclipses of it could come in horrific ways. He came home after the conflict wounded and much worse for wear, but he settled on the Piedmont clay in Edgefield and began to farm under a sun that mostly shined favorably on his efforts. Mamatha would've been thankful for the sun's return and probably linked it to God's favor for her and Daddy Joe. Disfavor would've been him dying at the hands of the Huns—I'm not sure the sun would've ever shone for her beyond such a possibility. The blinding, she would likely say, would have come from being disobedient to God; punishment for sin and wrongdoing. Daddy Joe and Mamatha farmed and raised

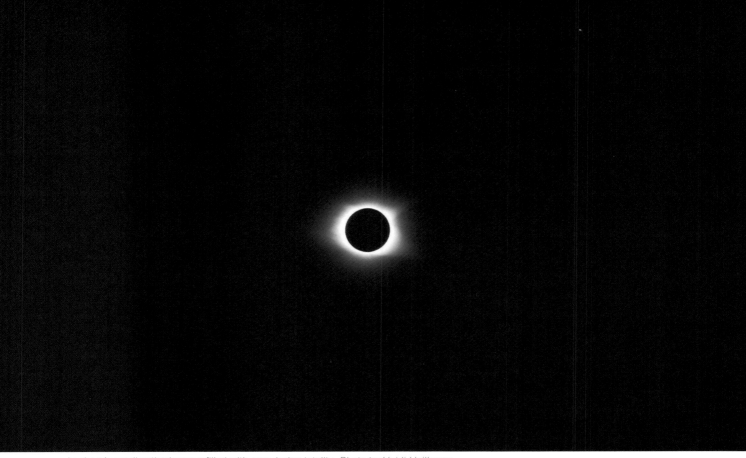

Lanham's small gathering was filled with awe during totality. *Photo by Heidi Heilbrunn*

a family, and I am the product of that persistence, sitting here now under a sun that is about to go away.

Growing up in the shadow of someone who almost daily talked about totalities in other often horrifying ways can lead to certain dispositions of awareness. I'm one of those people who is constantly waiting for some wheel to fall off whatever situation seems to be too good to be true. Today, I was worried about clouds obscuring the view or birds not being out for me to observe and write about. None of these are things I could possibly control; yet I worried. But the few clouds that created the concern early on have moved on. The birds also cooperated, and I relaxed into the countdown to an event that I will not be alive to see again.

Today, we watch the modern convergence beneath a darkening sky. There's an eeriness to it all. The normally washed out colors of the mid-summer day are vivifying. A greenish cast emerges and flows across the fescue pasture. I can still see a few ducks on the pond but most seem to have congregated in a couple of small flocks, just as we have. I choose to do things my grandmother wouldn't have ever approved of—not going to church; going into wild remote places where I might get attacked or eaten by some beast; imitating owls and drawing bad luck upon myself; staring into and celebrating the eclipsing sun instead of cowering in fear and praying for its return. Growing up like I did and straddling these worlds of mystic and science make days like this one all the more special to me.

With the only thing between me and blindness being a flimsy pair of cardboard shades, I'm trying to be the observant ornithologist. How will the birds react? I'm usually out here early in the morning or late afternoon when the avian activity peaks. Just a month or so ago, meadowlarks, dickcissels, grasshopper sparrows, blue grosbeaks, and a host of other birds would've been flitting and flying about, males teed up on fence posts or belting out arias from ripening sunflower heads, singing to defend territories and attract mates. I'm looking up for the celestial totality but then too for what the birds are doing. Daylight fades. An American goldfinch twitters its up-and-down song as the crescent of sun remaining wanes. It seems like we've been waiting for a long time, but it's been less than an hour. The kettle of turkey vultures had long since boiled away over the ridge along with the manslaughter of crows that had also been unusually silent in their departure from lunch. A Eurasian collared dove hooted at the settling dusk—"coo-cooooahhh … coo-cooooahhhh"—almost owl-like. Someone thought they'd heard a coyote wail. The sliver of sun left in the sky was now casting an amber glow on everything. It was the most wonderfully pleasing otherworldly glow: twilight with a different edge; a dimly lit room flickering in the ebbing essence of a galactic candle. With each second drawn closer to totality, we all seemed to be bound closer by the blurrying horizons we could barely see and an infinity we could only imagine. The bird-centric banter and laughter fell to whispers with the temperature. And then the sun was suddenly gone and a bright ring of light was all that remained. The whispers crescendoed beyond awe and disbelief and rose in the

melding of sun and moon shadow to a full-throated ode to solar joy! However one chooses to define awe—maybe as surprise and wonderment tinted with unspeakable happiness bordering on delightful delirium—it spilled from the small gathering and erupted skyward. Mamatha would've called what happened "shouting" and declared our celebration praise-worthy. A flock of mourning doves flew low and fast across the road. Whether they were spooked by the outburst or the sun's disappearance isn't something I could ever know. The data was bliss-biased and certainly non-normally distributed. A blue grosbeak threw a warbled song from somewhere out in the field of spent sunflowers. A Carolina wren called and then, as I remembered to breathe again, the sun re-emerged. I hadn't prayed for it to return but there it was. The ducks still swam on the pond and the killdeer and sandpipers resumed their skittering. A squadron of swallows—trees, cliffs and northern roughed wings—appeared out of nowhere, flitting about in the kind of reckless, weightless abandon that swallows do. I accepted them as post-totality gifts for our list. We ended up with a scant twenty-three species and the realization that birds probably weren't as jostled by things as we were. A randomly hurled song here and there was about all we could pin down. Connecting cause to the cosmos was at best, a guess. It makes sense. After all, birds have had millions of years seeing totalities that we can't even fathom. The adjustment to a single event in the grand scheme of things is likely just a winged shoulder shrug for them. For us, though, it was two and a half minutes of unfiltered awe that'll have to do for the next 200 years. Those are stats beyond my control, and I'm okay with that.

Once again, the great yellow orb glowed full tilt in the sky. The heat returned with it and we downed the last few beers in celebration. We reveled in the reveal, basking in the new sun day and rejoicing in the view of a singular life event that we'd all just witnessed—together. For all that solitude means to me, I was happy to have shared something wondrous and spectacular with kindred spirits. Birds and nature were a conduit in the happening. My grandmother used to talk about the importance of church. Of course, it was supposed to be "God's house" and a temple for worship. But then she used to talk about the importance of the social component—of gathering together. "Where two or more are gathered …" she used to say. Here we were, a dozen or so souls under heaven's gaze, looking up in wonder at something worthy of worship—the source of our very lives on Earth. For me, it was church in a real sort of ungodly but yet sacred way. I think even my grandmother might have found some good in that. It's funny how what we don't believe in often becomes the critical lesson in believing in something else.

DR. J. DREW LANHAM (B.A. Zoology 1988; M.S. Zoology 1990; Ph.D. Forest Resources 1997) is a native of Edgefield and Aiken, South Carolina. In his twenty-two years as a member of Clemson University's faculty, he's worked to understand how forest management impacts wildlife and how human beings think about nature. Lanham holds an endowed chair as an Alumni Distinguished Professor and was named an Alumni Master Teacher in 2012. His board memberships include the South Carolina Wildlife Federation, South Carolina Audubon, Aldo Leopold Foundation, BirdNote, and the American Birding Association. Lanham is a widely published author and award-nominated poet, writing about his experiences as a birder, hunter, and wild wandering soul. His work and opinions have been featured on National Public Radio, National Geographic online, *USA Today*, the *New York Times*, and *Slate*. As an essayist, Lanham has found footing in several anthologies, such as *American Crisis*, *Southern Solutions: From Where We Stand-Promise and Peril*; *The Colors of Nature*; *Bartram's Living Legacy: The Travels and Nature of the South*; *Outdoors in the Upstate*; *South Carolina Writers and Their Dogs*; *Carolina Writers at Home*; and *State of the Heart: South Carolina Writers and the Places they Love*. His first solo works, *The Home Place: A Colored Man's Love Affair with Nature*, and a chapbook of poetry, *Sparrow Envy*, were published recently.

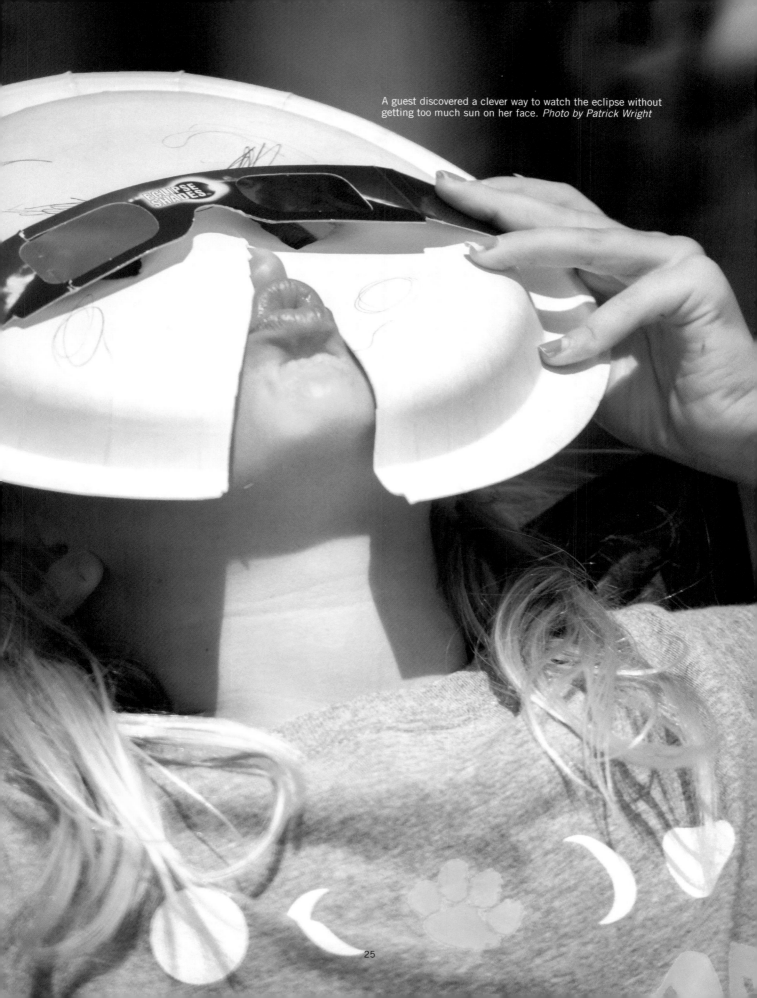

A guest discovered a clever way to watch the eclipse without getting too much sun on her face. *Photo by Patrick Wright*

CLOCKWISE FROM TOP LEFT: A team of scientists from the University of Maine held a balloon-launching experiment at Clemson. The balloon, which rose to about 100,000 feet, carried a variety of cameras and other equipment that were used to live-stream the eclipse and conduct other experiments. For more information about the experiment, go to www.umhab.org. *Photo by Ashley Jones*; The Tiger mascot and a young guest enjoy a hug before the start of the eclipse. *Photo by Ashley Jones*; A guest made herself comfortable while watching the eclipse. *Photo by Pete Martin*; Clemson University president Jim Clements pointed at the sky as totality approached. *Photo by Ashley Jones*

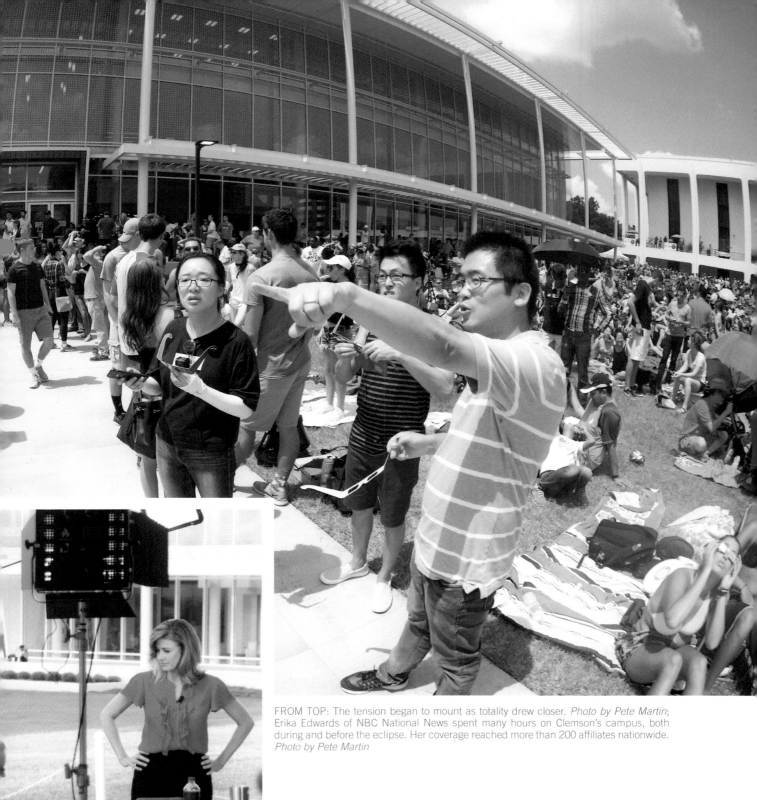

FROM TOP: The tension began to mount as totality drew closer. *Photo by Pete Martin*; Erika Edwards of NBC National News spent many hours on Clemson's campus, both during and before the eclipse. Her coverage reached more than 200 affiliates nationwide. *Photo by Pete Martin*

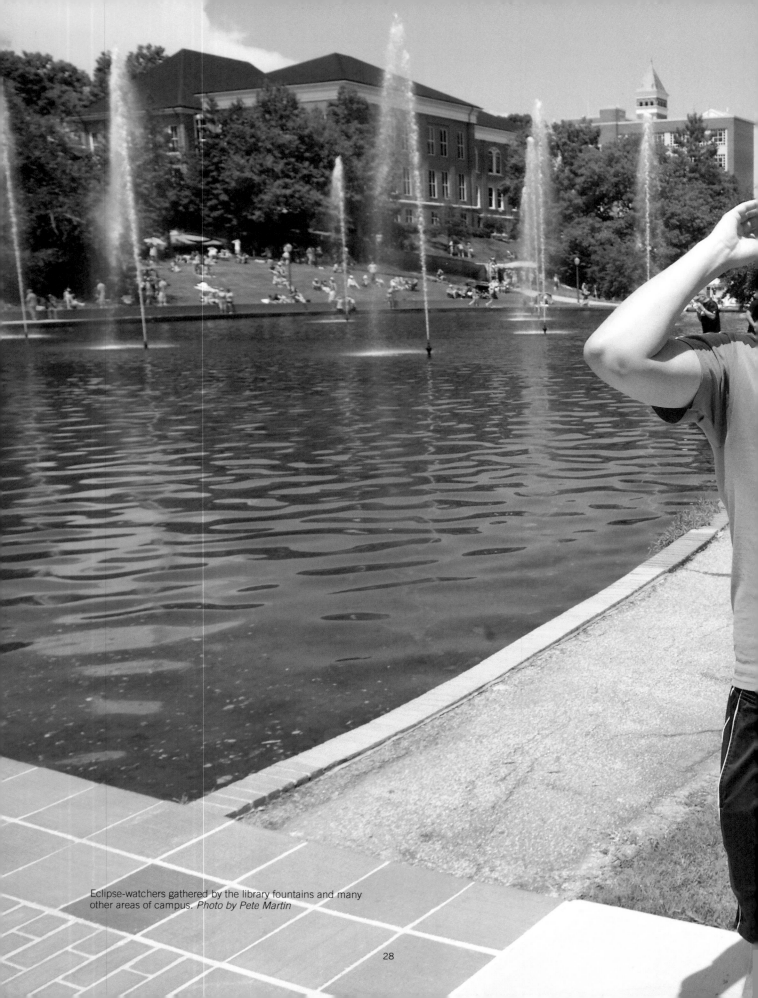

Eclipse-watchers gathered by the library fountains and many other areas of campus. *Photo by Pete Martin*

28

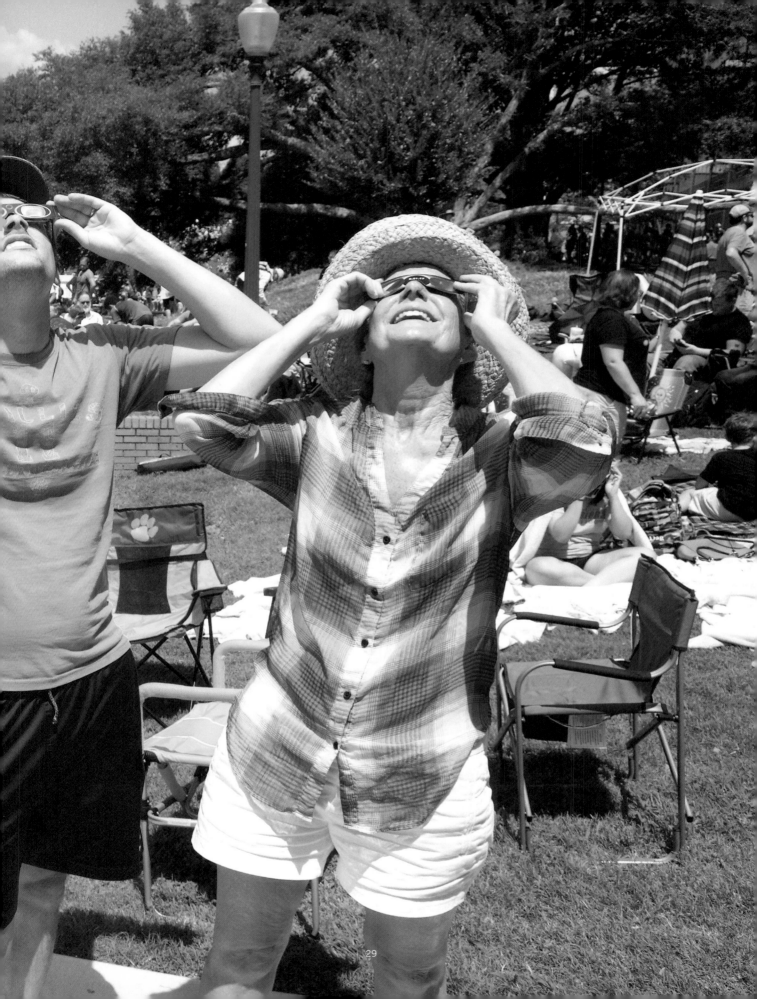

Dr. Mark Leising (right) put on an eclipse demonstration for the crowd using a variety of colorful props. *Photo by Pete Martin*

STUNNING SCIENCE

DR. MARK LEISING
PROFESSOR, DEPARTMENT OF PHYSICS AND ASTRONOMY

A Clemson University astrophysicist who has witnessed and studied many cosmic wonders ranks the total solar eclipse at the top of his list.

IN THE DEPARTMENT OF PHYSICS AND ASTRONOMY, WE BEGAN preparing for the 2017 total solar eclipse in 2011, when we installed a digital projection system in our planetarium. We customized a short vignette that had come with the system to show the progress of the August 2017 eclipse, as seen from Clemson, on the planetarium dome.

In the last half-dozen years, thousands of planetarium visitors learned about the impending eclipse. Since 2013, we heard often from eager alumni and eclipse fans hoping to experience the event here on campus, which we encouraged without really knowing what we would eventually do.

From mid-2016, the College of Science presented the total solar eclipse to university leaders as a unique opportunity for our campus. Subsequently, university unit leaders gathered to discuss the planning for the event, especially as our estimates of possible attendance surged from 5,000 to 50,000 or more. Our campus public-information professionals were among the first to recognize the full potential for generating media and public interest in the eclipse, and they were active participants in the

planning from early in the process. Our idea of the location for the main viewing area moved from the athletic district, to the Lake Hartwell dike, and finally to the academic center of campus.

Just in time, funding for the event arose in extraordinary fashion. Within hours of being asked to contribute to our cause, every one of our college and library deans pledged financial support from their faculties' entrepreneurial revenues. Appropriately, "Eclipse Over Clemson" became principally an academic event.

Our outstanding organizers, Jim Melvin of the College of Science, Dr. Amber Porter of physics and astronomy, and event planner Flourish Events, gathered the necessary partners. National media, on an unprecedented scale, converged on our campus. The university's safety, transportation, building, and electrical support teams rose to meet the challenge. Student volunteers enthusiastically joined our effort. It became clear that our "Eclipse Over Clemson" event would be a success.

If … the weather was clear on August 21. What do those clouds in the fifteen-day forecast mean? Does the lightning bolt

for next Monday mean storms all day? Or will it be just the usual fifty-percent chance of thundershowers in the late afternoon?

As Eclipse Day approached, it became more and more likely that the day—although hot and humid—would be sunny. We made a fortuitous decision to encourage our visitors, who numbered in the tens of thousands even several hours before totality, to make use of our nearby academic buildings. The air conditioning and water fountains undoubtedly helped prevent our patrons from overheating. And in many buildings, our visitors were provided the opportunity to learn about Clemson University's research and education activities via numerous displays and posters. For a stretch of about nine hours starting around 7 a.m., the burgeoning crowd remained friendly, well behaved, and buzzing with excitement. Once the free eclipse solar shades were in hand, everyone assembled on campus seemed more than satisfied with our event and the services provided.

The experience of my first total solar eclipse did not disappoint. Watching the moon slowly cover the sun heightened the anticipation of totality. The first ninety minutes of partiality provided a fabulous opportunity for teaching and learning more than just eclipse basics. By 2:20 p.m., the sunlight had noticeably dimmed, the heat had eased, and the light and shadows took on a strange, clear-but-flat quality. I suspected that it was the reduced glare from scattered light.

A westward-moving cloud briefly covered the sun, and then passed. But another cloudbank in the south was following it. I estimated its speed and distance to the sun—it would be right there near totality. But in the next few minutes, these clouds evaporated and seemed to reform farther south. It became apparent that we would get a clear view of the eclipse totality.

When the photosphere disappeared and the corona leaped out, I literally staggered backward. In a fraction of a second, I thought, "Ah, I see what they mean," and, "yes—50,000 astronomers-for-a-day get to see this! Nothing can go wrong now." I simply stared for a while, until I noticed a dozen birds flying eastward. I then thought to listen, and I heard cicadas and tree frogs singing off toward Barre Hall in the southeast. Only then did I notice the murmurs and exclamations of the dense gathering behind me.

I took a small finder telescope from the stand where it served as a projector of the partial phases, and looked at the sun with it. The detail of the coronal strands and curtains was mesmerizing. I searched for a tiny crescent of Mercury, but could not find it. However, I quickly found Mars on the other side of the sun. That was enough artificial optics. Now, I just wanted to watch. Overused words such as "awesome" and "spectacular" found their places. Maybe for the first time, I could use "stunning" appropriately.

The sky did not become as dark as I had expected. The clouds outside the shadow of totality must have been scattering sunlight back beneath the shadow. It was just dark enough to see the brightest stars and planets with the naked eye. I looked for the earthshine, but could not clearly see it. When I guessed that there was about a minute left of totality, only about fifteen seconds actually remained. I did not think to look for the shadow bands before. But just after totality, I did briefly see the wavering stripes on the roof of the underground building upon which we stood. For some reason, they struck me as oddly unnatural.

The total solar eclipse was more physical and visceral than other astronomical or natural experiences. I recall the wonder I felt the first time I saw Saturn in a good telescope, or the Milky Way in a truly dark, moonless sky. Or when I stood next to Niagara Falls, or flew past Mount Etna's fiery caldera in the dark. Those moments were exciting too, but somehow more intellectually so. I have witnessed new discoveries in astronomy, firsts that other researchers sought but that we were fortunate to see play out on a computer screen over weeks or months. These are built on tremendous theoretical and observational scientific edifices and are immensely exciting and satisfying to scientists, but not in the way the eclipse was. The experience of watching the space shuttle launched with our experiment aboard was dramatic, from the physical power of the engines resonating in my chest and the uncertainty inherent in space launches. Still, the rare disruption and wonder of a total solar eclipse is disconcerting and fascinating in a manner that does not compare to anything else. Perhaps our connection to the sun is simply more direct, with little abstraction.

What should we take from this event in the twenty-first century? What is the real value of this experience? Henri Poincaré, the French mathematician and scientist, wrote in 1907 that observation such as this:

> is useful because it raises us above ourselves; it is useful because it is grand. … It shows us how small is man's body, how great his mind, since his intelligence can embrace the whole of this dazzling immensity, where his body is only an obscure point, and enjoy its silent harmony. Thus we attain consciousness of our power, (which) makes us mightier.

Everyone can take something from this experience, without a single thought of "us" and "them." Orbital mechanics and light and shadow have no political or social bias. There is no contrary side. No king or president can do anything to hasten or prevent this eclipse, and no one owns all of the prime viewing locations, which span a continent. This event is so huge and inevitable that we all can share it.

And yet the universe that our minds embrace is so much larger than this. Moonlight travels about a second to reach Earth, while the sun is roughly eight light-minutes away. Compared to planets around other stars (one hundred light-years), exploding

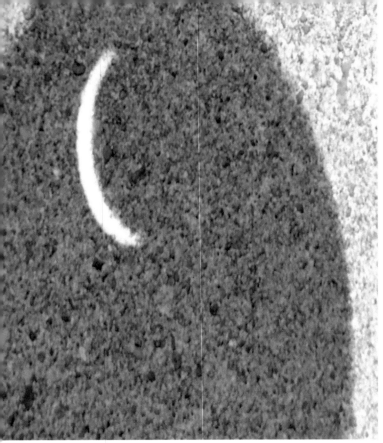

The crescent sun was projected onto the rooftop of the Strom Thurmond Institute using a small telescope. *Photo by Mark Leising*

thermonuclear supernovae (one hundred million light-years), or black holes swallowing stars at the centers of distant galaxies (billions of light-years away), all of which we now routinely study, the eclipse players are right here in our own back yard.

Background is a subject always on the minds of astronomers, but if we are careful and fortunate, we might hardly need to discuss it. The sky background (actually in the foreground) is why we do visible astronomy at night and high-energy X-ray and gamma-ray astronomy from orbit. In some measurements, nine-tenths of the effort is spent in understanding, controlling, and removing background to get at weak signals. So, it seems almost magical that the intense sunlight and bright sky background simply disappear for a few minutes during a total solar eclipse, as nature's perfect "coronagraph" slips into place. It is a useful metaphor for modern life—there is a great deal of background

glare and noise, but what lies underneath is where the most valuable lessons are learned.

Eclipses have been predicted with some accuracy for more than two millennia, although the underlying knowledge was lost at times and places, and had to be rediscovered. The ability of science to understand and therefore predict should not be underestimated or ignored. Rigorous science must be nurtured and used to our advantage, no matter if we like its predictions, and even if it is science not so thoroughly tested yet as is gravitation.

I admit that, at first, I cringed at the designation "Great American Eclipse." Objectively, this eclipse is neither great nor American. The moon always carves a roughly similar shadow in the sunlight somewhere, except during a lunar eclipse, and one who is fortunate enough to pass through the shadow cannot justifiably claim it. Still, if the moniker inspired us to talk about the eclipse and led millions to come together and see it for themselves, then maybe it was indeed great for America.

Once or twice during the late stages of planning for the "Eclipse Over Clemson" event, I thought that it might have been better to simply go to a remote hilltop with our astronomers and friends and spend our time enjoying the spectacle and measuring it with our telescopes and cameras. However, I am extremely glad that we chose to put on a large event open to everyone. Afterward, nearly one hundred people—families, media personalities, and workers—personally expressed their gratitude for being given the chance to witness the eclipse here on the campus of Clemson. I met visitors from five continents, who were moved to offer their thanks. (No doubt there were visitors here from South America, but I did not meet them.) I later heard from people around the nation that the eclipse coverage from Clemson was the best they had seen. I have watched the NBC and The Weather Channel videos many times since.

In my twenty-six years at Clemson University, I have seen gatherings of this scale for only football and astronomy. In the latter, everyone won.

DR. MARK LEISING was born and raised in northern Kentucky, and earned a B.S. in physics from the University of Notre Dame and M.S. and Ph.D. in space physics and astronomy from Rice University. He spent five years at the US Naval Research Laboratory, where he worked with NASA's Solar Maximum Mission and Compton Gamma Ray Observatory instruments and participated in the first discoveries of radioactivity in a supernova explosion. He continued this work at Clemson University, including several first measurements of supernova X-rays, the cosmic gamma-ray background, and electron-positron annihilation gamma rays. He has long championed new and better gamma-ray astronomy missions, including a current lunar orbiter concept employing the moon to eclipse cosmic sources. He served as chair of the Department of Physics and Astronomy from 2011–15 and as interim dean of the newly formed College of Science from 2015–17.

CLOCKWISE FROM TOP LEFT: *"I came here to see the eclipse because it's my first time."* — Angel Rodriguez (left), Seneca, South Carolina; *"It's my first time too. I'm five years old."* — Karla Rodriguez, Seneca, South Carolina ● *"After seeing the eclipse, I got a huge lump in my throat. You can't help that, because it's God's amazing handiwork. It was beautiful."* — Malinda Stephens, Powder Springs, Georgia; *"I was utterly amazed at what I saw. Pictures can't describe what you see in person."* —David Stephens, Powder Springs, Georgia ● *"I'm originally from Alabama, and I'm fifty years old. When I was in college, this guy next to me was my best friend. We were very sad because we had to go separate ways after graduation. Late one night, he said, 'Well you know, there's going to be a total solar eclipse when you're fifty. We should make a pact to see it together.' At the time, I was more involved with what was happening in the moment, so making that promise was easy at the time. Then, we lost touch on and off throughout the decades. Then, I turned fifty and I got a text out of the blue in January, and he came down from Myrtle Beach. We had a big celebration, and he toasted me at my dinner party, saying, 'I want you to remember that I have come for you. We are seeing this eclipse together.' So here we are!"* —Joy Ovington, Athens, Georgia ● *"This is a once-in-a-lifetime event. I was out surfing the Internet, and I saw where the path of the eclipse was going—Greenville, Spartanburg, Columbia—but then somehow I got thrown over to the Clemson page and it seemed to be much more organized. It looked like a great event. So, thank you all very much for having us."* —Richard Chilausky, Durham, North Carolina

CLOCKWISE FROM TOP LEFT: *"Up in Westboro, we only get to see about fifty percent of the eclipse, and I wanted to see totality. We looked at different places to see the eclipse along the Eastern Seaboard, and my wife did some Googling online and said: 'Hey, you know, Clemson is having this thing, this viewing party …' And I punched it in on Google Maps and got the overlay of the town and realized, wow, you all are smack in the middle of this. It doesn't get much better than that. So, this seemed like the ideal place."* —Louis Lung, Westboro, Massachusetts ● *"I just looked on the map for totality, and we found Seneca. It looked like a beautiful little town, and then I heard about Clemson having a big to-do, and I thought, 'Wow, let's go there!' The weather was so-so in probability, which was good. So, we traveled from Phoenix. I've been interested in astronomy since I was a boy, and I've read and heard about eclipses and totality my whole life. I always dreamed of seeing one, and this is the first one."* —John Tutora, Buckeye, Arizona; *"I think this is just going to be exciting. I wanted to be in an environment with a lot of people, so Clemson is perfect. Plus, the air conditioning and the facilities that you have here are perfect. We've met so many incredible people on this campus; it's just wonderful."* —Shirley Tutora, Buckeye, Arizona ● *"The darkside.net predicted one percent cloud cover in Clemson, but fifty percent in Columbia, so we came here from Chapel Hill, North Carolina, because of the weather. I expect it to get dark, and I would like to be up high where I can see the shadow approaching. It's remarkable. I'd like to see the next eclipse up high from a mountain, so I can watch the shadows come at about 2,000 miles per hour over the Earth."* —Patrick Mortell, Chapel Hill, North Carolina ● *"We came to Clemson because it was in the path of totality and it is reasonably close to Atlanta. There were good roads in and out, and the campus could handle the volume. I'd never seen an eclipse, so it was really cool. Seeing the prominences and how big they were, and how it changed from start to finish, was really cool. At the very end, before the sun peaked back around, you really could make out the bright, sparkly things from the craters of the moon that were Baily's beads. I had only read about those before, so that was really neat. I knew to look for it, but I still didn't quite expect it."* —Quincy Acklen (right), Roswell, Georgia

Dr. Cynthia Pury watched the eclipse from her home in Piedmont, South Carolina. *Photo by Emily V. Sandstrom*

RECONSTRUCTIONS OF "AWE"

DR. CYNTHIA L. S. PURY

PROFESSOR, COLLEGE OF BEHAVIORAL, SOCIAL AND HEALTH SCIENCES

Clemson professor studies the psychological effects of experiencing a powerful cosmic phenomenon.

ON AUGUST 21, 2017, I WITNESSED TOTALITY FROM MY DRIVEWAY with my husband and youngest daughter. It rapidly became dark when the moon cut off the last sliver of the sun, and we all removed our glasses and stared in awe at the corona. It was one of the most beautiful things I've ever seen. And it was exactly on time—to the second—of what had been predicted. I had expected this but found myself impressed, nonetheless.

After a while, my husband Craig said, "It's just what I remember from the eclipse when we were kids!"

"Huh?" I said. He and I had grown up in adjoining communities in southeastern Wisconsin, where we had our own eclipse in 1979. "I thought that was just a partial eclipse."

"No, it was a full eclipse. I remember looking at it with a pinhole, then the teachers all said it was safe to look up and we did. It was just like this."

Sigh. My mother was a good parent but she was overprotective. She made me promise—several times—to not look up when I left for school that morning in 1979, so I dutifully stared at the ground and missed it. At least I was getting another chance now. We watched the rest of the 2017 totality

in awe. Toward the very end, shadow-bands rippled along our driveway. Then it was over. I felt awed by the beauty we'd seen and gratitude that the totality went right over our house in a clear, deep-blue sky. A small part of me, though, felt peeved at my late mother for making me miss the same experience in middle school.

On Facebook, old friends were talking about the eclipse. "Remember watching that partial eclipse back in middle school?" one classmate said. "Yeah, with the pinholes? The sun made a crescent shape. And the teachers wouldn't let us look up!" Wait, partial eclipse?

"Hey," I said to Craig. "That was a partial eclipse when we were kids."

"No, it wasn't. It was a total eclipse. I watched it at my school. We didn't have the shadow bands, but I remember the corona."

"Huh," I said. Our schools were twelve miles apart, so I deduced that the line of totality must have gone right between the two. How cool is that? Science.

I googled "path of 1979 eclipse USA" and there it was: a

How did people describe the eclipse? This word cloud is based on all narratives of the 169 people in the path of totality who described their eclipse experience just after the event. Each word presented here was used by at least 10 people, with larger words used by more people. *Illustration by Cynthia Pury*

wide path cutting across Oregon, Washington, Idaho, Montana, and North Dakota before heading into Canada. The path of totality had missed Wisconsin by hundreds of miles. I showed my husband. He shook his head for a moment. Then we realized that we both had spent a good part of the afternoon remembering something that had never happened.

Fortunately, we know that memory is reconstructive. That is to say, memory doesn't work like a video that can be played back exactly the same way each time. Instead, memory is reconstructed each time we try to recall something. This reconstruction takes bits of the past and bits of what's going on now and puts together a plausible story. Usually, this works out just fine. Occasionally, people end up with what psychologist Elizabeth Loftus calls "false memories," or vivid recollections

of an event that never actually occurred. These memories can come from current experiences, like my husband thinking he'd seen a totality before, instead of just pictures of one. They can also happen when another person says it happened and you fill in plausible details, like me filling in my overprotective mother telling me to not look at totality. Sometimes, a false memory can even lead someone to have an emotional response to something that never happened, like me being angry at my mother for keeping me from seeing the non-existent Wisconsin totality. Even contradictory information can be fit into the story, like the edge of totality that did (not) run right between our towns.

One of the most useful things I've learned in psychology is to think of my own memory as reconstructive. If there's something I want to recall later, it is worth it to write it down or take a photo.

If I remember an event differently than someone else, the truth might be theirs, or mine, or neither of ours.

How will people remember the 2017 eclipse? While I certainly did not expect to experience a false memory firsthand during the eclipse, I did expect that memories of the eclipse might change over time. When College of Science director of communications Jim Melvin contacted researchers across the university about participating in the "Eclipse Over Clemson" event, Darlene Edewaard and I separately realized that we could design a study to look at the things we are interested in—in my case, how people's memory of an awe-inducing event changes over time.

Awe is a sense of vastness that needs to be integrated with your understanding of the world. Like many emotions, it can be measured as what you are feeling right now; in this case, "state awe," and how often and easily you experience it in general, or "trait awe." As a positive psychologist, I'm also interested in people's strengths, or long-standing areas of excellence. Although we often look at specific strengths—such as curiosity, appreciation of beauty, kindness, justice, perseverance, and prudence—recently these have been combined into three aggregate factors: intellectual strengths (like curiosity and appreciation of beauty); interpersonal strengths (like kindness and justice); and self-regulatory strengths (like perseverance and prudence). As a beautiful, astronomical phenomenon, I predicted that the eclipse would inspire the most awe in people who were high in intellectual strengths, in addition to those high in "trait awe."

Darlene and I created a series of online surveys for people who planned to watch the eclipse. Anyone interested completed a measure of how frequently they feel awe, a measure of a variety of positive personal strengths, and a measure of how dark they expected the height of the eclipse to be (which is discussed in her chapter). Then, if they were interested, they gave us their email address to be contacted again. More than 200 people— including 169 in the path of totality—completed a second measure right after the eclipse, asking them to describe the eclipse and how much awe they experienced in response to it.

Although data on their memories of the eclipse and the awe it produced are still being gathered as this book goes to press, our initial results for the emotional measures found that among people in totality, a combination of having lots of "trait awe," high levels of intellectual strengths, and lower levels of self-control strengths predicted "state awe" during the eclipse. Looking at people's descriptions of their experience during the eclipse, we also found that people who experienced higher levels of awe used language that was focused on the present. They also used more exclamation marks. In other words, the awe experienced during the totality represented a moment of focused, unrestrained, geeky joy!!!

DR. CYNTHIA PURY is a professor of psychology, having joined the Department of Psychology in 1998. She holds a Ph.D. in clinical psychology from Northwestern University (1998). Her original research focused on fear and cognition. In the early 2000s she became interested in positive psychology, or the study of positive traits and states. She currently serves as an associate editor for the Journal of Positive Psychology and is the co-editor, with Shane Lopez, of the book *The Psychology of Courage: Modern Research on an Ancient Virtue.* Her current research focuses on courage, virtue, and other positive states and traits.

Darlene Edewaard, a Ph.D. student in the Department of Psychology at Clemson University, conducted several experiments during the eclipse. *Photo by Julie Edewaard*

PERSPECTIVE OF A "VISION SCIENTIST"
DARLENE EDEWAARD
GRADUATE STUDENT, DEPARTMENT OF PSYCHOLOGY

A research specialist is thrilled to witness the eclipse with her own eyes while collecting data on the visual perceptions of others.

ON AUGUST 21, 2017, I ARRIVED ON CAMPUS AT 8 A.M. WITH my sister Julie and my friend Anastasia to get a parking spot and stake out a good observing position in the grassy field near the Watt Family Innovation Center, where the main stage of the Clemson eclipse events was located.

We walked around campus to experience the commotion in different areas and felt the excitement growing as the area became more crowded with eager observers who had traveled from near and far to be in the path of totality. At 11:30 a.m., we moved to a shady spot under a tree beside our previously scouted observation point. I began to prepare my equipment, which included a pinhole telescope that I had made by poking a hole on one side of a cardboard box with a thumbtack, solar eclipse shades, a Minolta illumination meter, maps of the sky during totality, and a notebook and pen.

While enjoying the shade beneath the tree, Anastasia, Julie,

and I met two strangers who had traveled from Washington, D.C. to witness the eclipse. I grew even more excited as I looked around at the crowd, knowing that there were many people on campus from all over the nation anticipating the upcoming celestial phenomenon. With such a large crowd, I made sure that I was able to quickly and easily move to a sunny area when the eclipse began to provide a good view.

My plan was to primarily use the pinhole telescope to view the eclipse, take measurements of the illumination of the sky approximately every fifteen minutes, observe the crowd's reaction, talk to as many people as possible to find out what they were experiencing, and otherwise take it all in. At one hour before first contact, I tested the illumination meter and took my first reading. The meter was maxed out at more than 100,000 lux (a unit of illumination), which objectively verified that the sunny sky was extremely bright.

When the total solar eclipse began at 1:07 p.m., my stomach felt like it was filled with butterflies. The enthusiasm of the crowd grew as well. I sprang into action, moving my equipment to the nearby cement pathway that was in direct sunlight. The illumination meter still read 100,000 lux, but in the solar telescope, I could see that a small bite had been taken out of the sun. As the eclipse progressed, the ambient illumination gradually decreased. I stayed in my position, even though the sun was beating down on me. It was hot! I didn't care. The importance of getting a good view of the eclipse and not missing any part of it far outweighed my need to cool off.

During the time leading up to totality, people stopped by to learn how the pinhole telescope worked and look at the eclipse projection it produced. With all the attention we were receiving, Anastasia jokingly exclaimed, "We're charging a quarter per glance into the telescope." One man gleefully handed me a quarter. When I tried to give it back, he told me he wanted me to keep it because he was happy I had showed his daughter how the pinhole telescope worked. It amazed me how the eclipse was igniting the crowd's zest for science and creating a bonding experience between scientists and casual observers.

Finally, 2:37 p.m. arrived and the moon fully obstructed the light of the sun. Totality! My hands started shaking with excitement as I fumbled for the illumination meter. I could not believe my eyes as I read the meter: 2.13 lux. I gasped. Knowing that the illumination of the environment went from 100,000 lux at the start of the eclipse down to slightly over two lux during totality was enough to send jolts of adrenaline through my body. Yet, when I looked around at my surroundings, which appeared as dark as twilight, I did not perceive my environment to be as dark as I had expected. I had anticipated that the brightness of the sky would be closer to what it is at nighttime.

Suddenly, everything fell silent and time seemed to stand still. I looked up at totality and was struck by the inability to put into words what I saw and felt. Tears welled up in my eyes as I witnessed the beautiful diamond ring, and I was so overwhelmed that I was unable to recall the phenomena I wanted to see during totality. I tried to take a picture with my new iPhone, but I was too distracted by what was happening to adjust the light settings on the camera. I did not want to miss even one second of the spectacle, and I knew that totality would be photographed by professional photographers, anyway. As I looked around, I marveled at the 360-degree sunset and observed Jupiter and Venus.

Toward the end of totality, I focused my attention on the cheering crowd, and as the sunlight began to re-emerge, I noticed shadow snakes slithering across the ground. The crowd kept cheering as the sunlight grew suddenly brighter. Two minutes after totality ended, my illumination meter jumped from about two lux to more than 1,000.

The ambient illumination continued to increase as the sun

Edewaard's equipment included a pinhole telescope made by poking a hole on one side of a cardboard box with a thumbtack, solar eclipse shades, a Minolta illumination meter, maps of the sky during totality, and a notebook and pen. *Photo by Darlene Edewaard*

was unveiled by the moon. I began asking people around me what they saw during totality.

"A ring of light around the moon," Anastasia said.

"The corona formed a shape like a Star of David," said Tatiana, another friend who had joined us.

Julie marveled that she had seen the diamond ring. Several people packing up to leave commented that the sky did not become as dark as they expected, but they were still moved by the experience.

Clemson's campus reverted back to normal after the eclipse, but the people who were there that day will never be the same. I know with certainty that I will never be the same.

HOW DO HUMANS PERCEIVE ECLIPSES?

The viewing of a total solar eclipse is a visually stunning phenomenon that depends on the occurrence of various perceptual and physiological factors. For instance, the sun and moon must appear to be the same size in the sky in order for the moon to completely block the sun and allow totality to occur. In addition, an observer must be positioned in the path of totality, and light emanating from the sun must enter an observer's eyes and be converted into meaningful images by the brain. Throughout all this, observers must use special methods to protect their eyesight while observing the eclipse, except during totality.

Visual angles and viewing angles are external perceptual factors that pertain to the observation of eclipses, but physiological factors also play a key role in an observer's ability to see an eclipse. Put simply, the human eye consists of multiple components that function together in order to allow observers to visually perceive their environments. First, light enters the eyes through the pupil, or the dark window in the center of the colored portion of the eye. The pupil automatically adjusts its diameter in

response to the amount of ambient light in the environment by becoming smaller in brighter conditions (such as the beginning of the solar eclipse) and larger in dimmer conditions (such as during totality when light from the sun is obstructed by the moon).

After passing through the pupil, the light is further focused by the lens in the eye and projected onto a membrane located in the back of the eyeball, called the retina. The retina is home to important cells that process light, known as photoreceptors. There are two different types of photoreceptors, which convert light into energy that can be sent to and processed by the brain. In the brain, there are certain cells that specifically process information pertaining to various aspects of our visual environments, such as motion, color, contrast, and object

orientation. The visual information processed by these cells is pieced together to allow an observer to understand his or her visual environment. Therefore, when observers view a total solar eclipse, the eyes and the brain work together to create a meaningful and holistic representation of the progression of the moon blocking out the sun.

THE 2017 ECLIPSE STUDY

In the responses to the first survey that Dr. Cynthia Pury and I created for the 2017 Eclipse Study, 159 observers who witnessed totality provided estimations in the first survey of how bright they expected the sky to be before the eclipse started and during totality on a scale of one (the sky at night) to ten (the sky on a clear, sunny day). For the second survey, the same observers provided judgments of how bright they perceived the sky to be before the eclipse began and during totality on the same 1–10 scale. The results of the analyses of the brightness judgments indicated that the observers expected the sky to become significantly darker during totality than it was before the eclipse began. Further, the observers perceived a significant decrease in brightness of the sky during totality compared to the sky before the eclipse. However, observers expected the sky to be significantly darker during totality than they actually perceived the sky to be.

In descriptions of their experiences, many observers commented that the sky did not get as dark as they had expected. In terms of objective measurements of ambient illumination, the illumination of the nighttime sky is typically 0.01 lux, which is significantly lower than the 2.13 lux measurement taken from the illumination meter I used during totality. Still, many observers were astounded by the opportunity to see the diamond-ring effect, Baily's Beads, the corona, planets such as Jupiter and Venus, and shadow snakes. These findings suggest that the total solar eclipse of 2017 spurred widespread enthusiasm for astronomy and gave observers an appreciation of our place in the solar system.

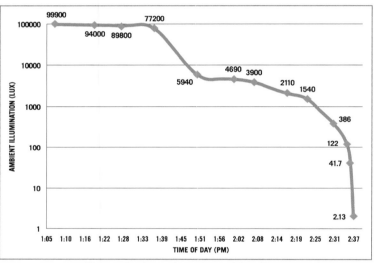

The graph above shows the ambient illumination levels in lux from the start of the eclipse at 1:07 p.m. until totality occurred at 2:37 p.m. Greater levels of ambient light signify brighter lighting conditions, whereas lower levels of ambient light signify darker environments.

DARLENE EDEWAARD is a Ph.D. student in the Department of Psychology. She holds a master's degree in applied psychology and plans to obtain her Ph.D. in human factors psychology in May 2019. She has continued to pursue her passion for conducting research on vision science since 2012. In addition, she also has been an amateur astronomer for over ten years and has experience with both optical and radio astronomy. A few of her early research studies, which have been presented at national and international conferences, have focused on human visual perception as it pertains to astronomical events, such as audio/visual interactions and brightness and duration perception of meteoric events during meteor showers, as well as size and distance perception of the moon illusion. Currently, she is the president of the Clemson student chapter of the Human Factors and Ergonomics Society, and she is also a graduate research assistant in the Visual Perception and Performance Laboratory. Her research focuses on the implications of vision science on transportation safety.

A guest bent over backward to get a bird's-eye view of the eclipse.
Photo by Heidi Heilbrunn

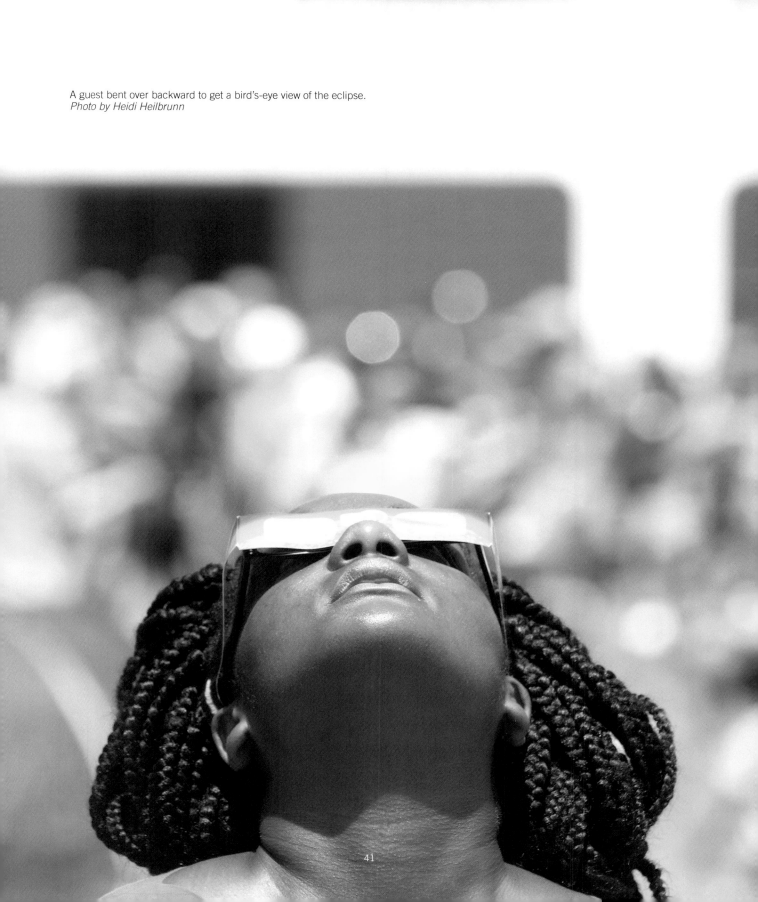

41

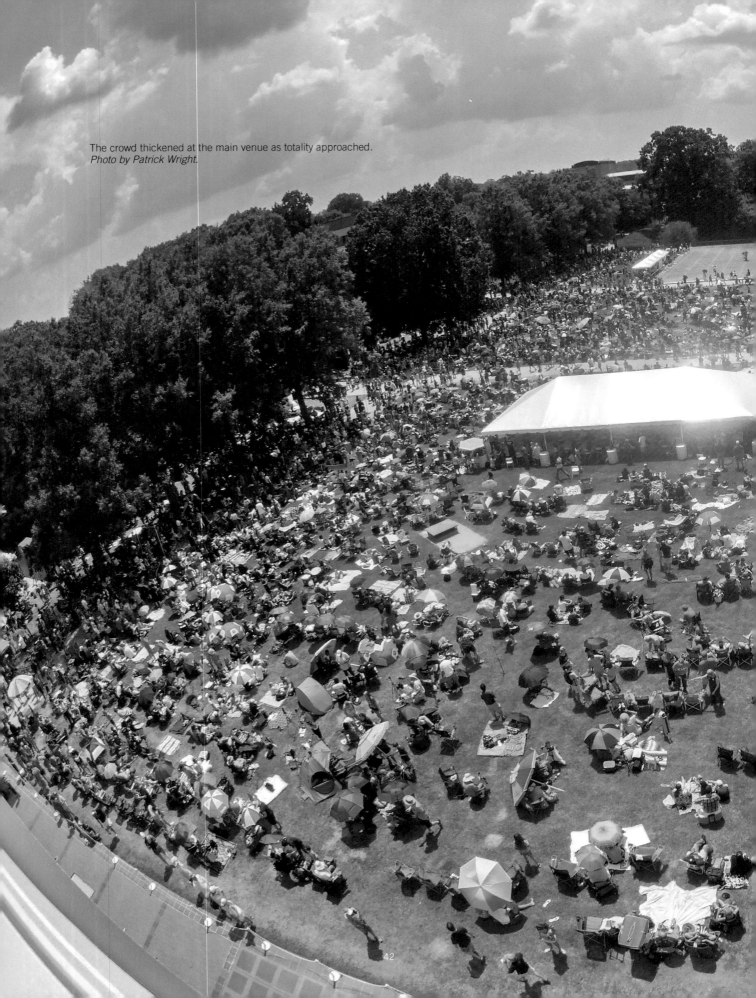

The crowd thickened at the main venue as totality approached.
Photo by Patrick Wright.

42

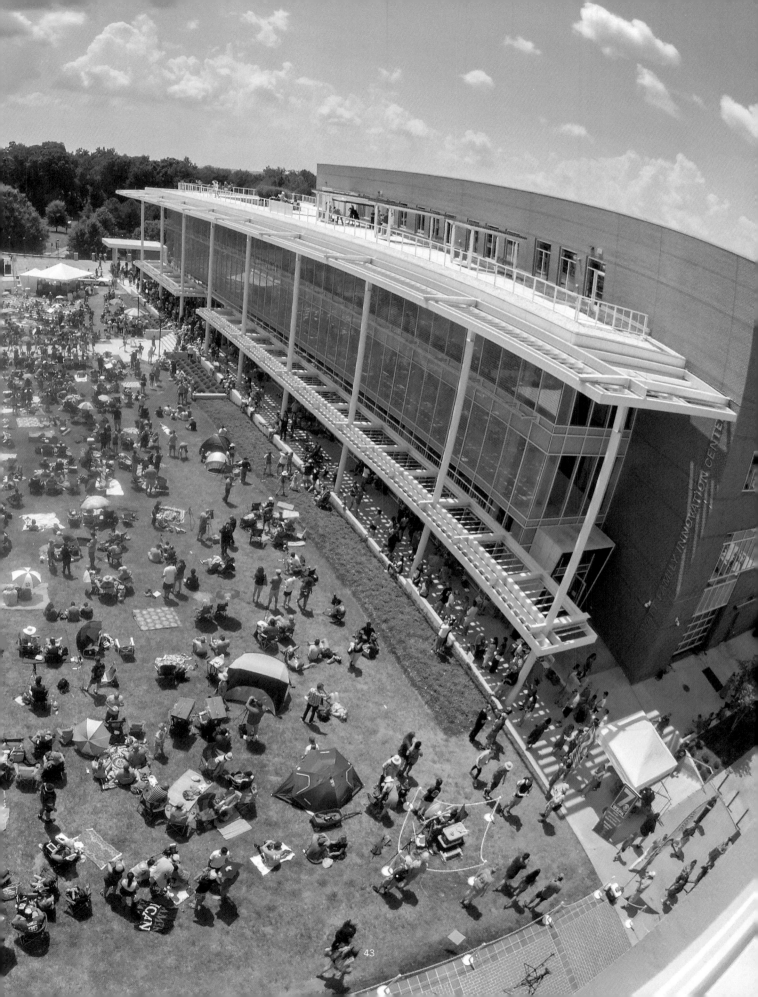

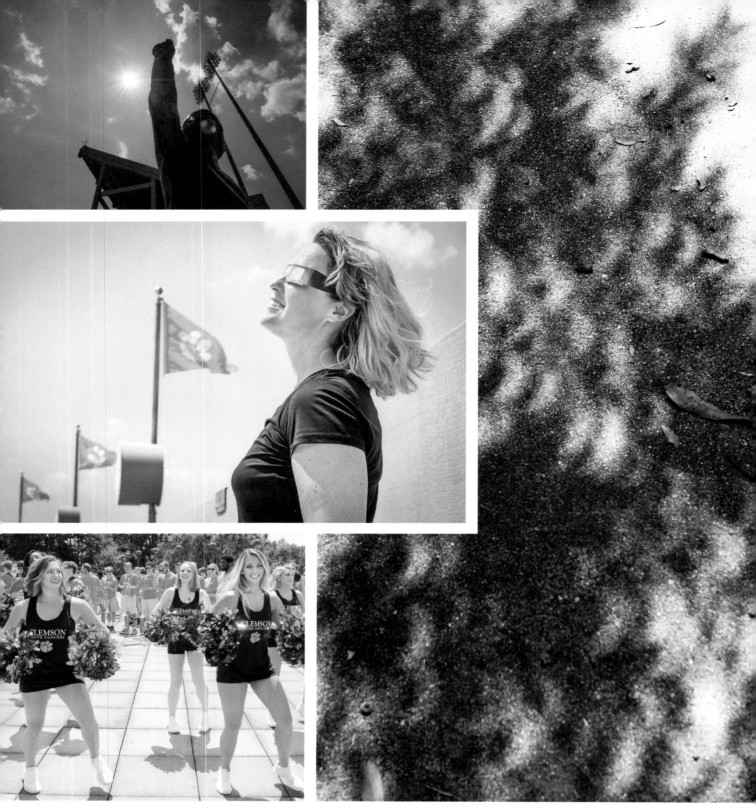

CLOCKWISE FROM TOP LEFT: The sun glowed near the start of totality over the Tiger statue near Gate 1 at Memorial Stadium. *Photo by Ashley Jones*; The tiny gaps between leaves acted as pinhole lenses, projecting crescent-shaped images of the eclipsed sun onto a sidewalk. *Photo by Ashley Jones*; The renowned Tiger Band performed during the eclipse. *Photo by Pete Martin*; Janna Lemur watched the eclipse from atop Memorial Stadium. *Photo by Ken Scar*

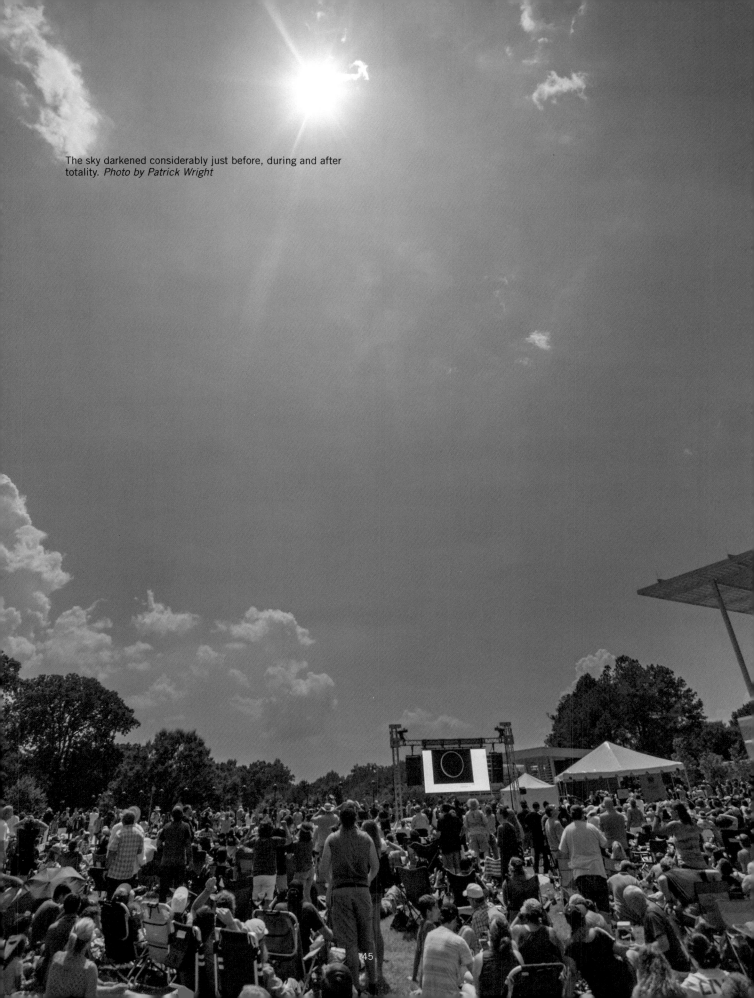

The sky darkened considerably just before, during and after totality. *Photo by Patrick Wright*

45

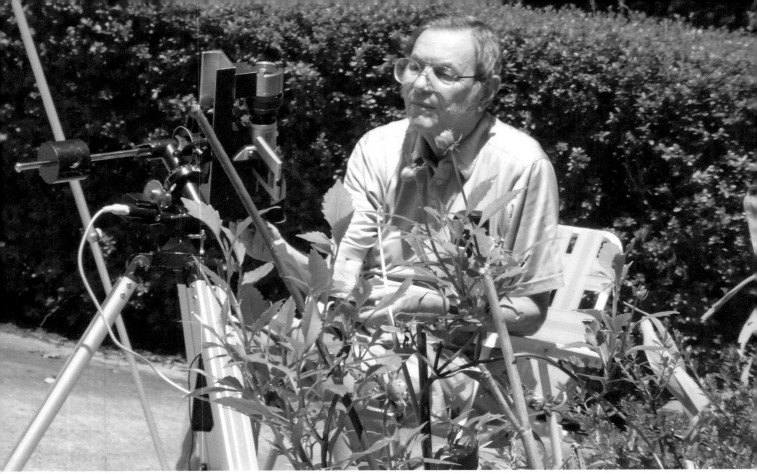

Dr. Donald Liebenberg watched and researched the eclipse from his driveway in Salem, South Carolina. *Photo by Norma Liebenberg*

FAMED SCIENTIST'S TWENTY-SEVENTH ECLIPSE RANKS WITH THE BEST

DR. DONALD LIEBENBERG
ADJUNCT PROFESSOR, DEPARTMENT OF PHYSICS AND ASTRONOMY

Dr. Donald Liebenberg has literally traveled the world to research total solar eclipses. He even studied one from the cabin of a Concorde supersonic jet. He watched the August 21 eclipse from his own driveway.

ON AUGUST 21, 2017, I VIEWED AND RESEARCHED MY TWENTY-seventh total solar eclipse from my driveway in Salem, South Carolina, in the company of seven family members, including my wife, Norma.

Some threatening clouds had us all a bit worried, but the sky was clear during totality, giving us an awesome view of the corona.

My FeXIV emission line digital record turned out to be superb, with the inner corona showing many features that will take some time to process. This is fluorescence from iron in the corona that is so hot that thirteen of its electrons—one-half of its total number—are missing.

Eclipse number twenty-seven ranked with the best I've ever seen, and the two-minute-and-thirty-seven-second totality astounded me as much as any other.

During my decades of research regarding total solar eclipses, I have learned as much about myself as I have about

the sun's corona. My adventures have helped shape me as a scientist and as a man.

My study of solar physics—particularly my research on the paradox that the surface of the sun is about 10,000 degrees, while its coronal emissions reach millions of degrees—has been scientifically valuable and personally rewarding. I have benefitted from interactions with many people and will describe some of them in this summary. But it would be impossible to mention everyone. I owe debts of gratitude to multitudes. Without their help, I could not have accomplished nearly as much as I did.

My eclipse and solar studies were undertaken in the context of research and of the duties of my employment. Here are some of my career highlights:

- My doctoral degree, obtained at the University of Wisconsin, involved research—alongside Dr. J. R. Dillinger—into the behavior of superfluid helium film flow.

- At Los Alamos National Laboratory (LANL), I initially worked with the low-temperature group and with Dr. Ed Hammel and Dr. Frederick Edeskuty in the design and testing of large liquid hydrogen storage and flow for the nuclear rocket program. The development of a gas chromatograph for analysis of hydrogen delivered to the test site was another accomplishment. A company produced three of them for LANL.
- I worked with Dr. Bob Mills, Leroy Schmidt, and John Bronson in high-pressure studies to determine the equation-of-state of several gases in a piston-cylinder apparatus.
- I brought the high-pressure diamond anvil cell (DAC) designs from the Carnegie Institute. Our group was the first to capture a gas in the DAC and measure the room temperature solidification of helium and hydrogen gases.
- I was attached to the new Laser Division Office at LANL and coordinated the deuterium (heavy hydrogen) target development. A Faraday polarization selector—a device that transmits light at one polarization angle and blocks light polarized at other angles—resulted from this research.
- For a year and a half, I took a leave of absence from LANL to become program director for Solar Terrestrial Research at the National Science Foundation (NSF), and then another leave of absence from LANL to take an NSF position as Program Director for Low Temperature Physics. I supported US work on superconductivity that advanced high-temperature superconductor development and other research.
- I spent one year at the Department of Energy (DOE) as a program manager in Condensed Matter/Basic Energy Sciences (BES).
- I then moved to the Office of Naval Research (ONR) as a scientific officer to help develop high-temperature superconductivity applications for the US Navy and the Department of Defense.

After thirty-four years performing these various duties, I retired to South Carolina with my wife Norma and became an adjunct professor in the Department of Physics and Astronomy at Clemson University. Since then, I've worked primarily with Professor Terry Tritt's research group. I've also worked extensively with Apparao Rao, Jian He, and others.

All twenty-seven total solar eclipses that I have witnessed during my lifetime have stimulated me. Are there any new words to describe this unique wonder of the cosmos?

Each time that totality begins, I silently honor the many early and more-recent efforts by astronomers and mathematicians to accurately predict when and where a total eclipse will occur.

In aircraft, I have marveled at how the pilots and navigators have been able to have their planes be overtaken by totality in the

THE LIEBENBERG CHRONICLES— ECLIPSES 1–26
JIM MELVIN
DIRECTOR OF COMMUNICATIONS, COLLEGE OF SCIENCE

Before the August 21 eclipse, Clemson University scientist Dr. Donald Liebenberg had personally witnessed and researched twenty-six total solar eclipses over the past sixty-plus years. In the months leading up to "Eclipse Over Clemson," Liebenberg shared his adventures in a sixteen-part series titled "26 and Counting: The Liebenberg Chronicles."

Liebenberg's first eclipse was on June 30, 1954 in Mellen, Wisconsin. His twenty-seventh was on August 21, 2017, in his driveway in Salem, South Carolina.

Liebenberg, who has been an adjunct professor in the College of Science's Department of Physics and Astronomy since 1996, has traveled literally all over the world to enter the path of totality of solar eclipses. He has studied them from the ground, on ships in the middle of oceans, and in airplanes. He even watched one eclipse from the cabin of a Concorde supersonic jetliner (see painting on page 49), where he was able to remain within the window of totality for an astounding seventy-four minutes.

All told, Liebenberg has spent more than two and a half hours in totality, which surpasses anyone else on Earth.

The story that appears in this book, titled "Famed scientist's twenty-seventh eclipse ranks with the best," is the latest installment of his amazing adventures. And if Liebenberg has anything to say about it, his twenty-seventh eclipse will certainly not be his last.

All sixteen segments (several segments were condensed to contain multiple eclipses) of "26 and Counting: The Liebenberg Chronicles" can be found here: http://bit.ly/2f08Tb7.

This map shows all 27 total solar eclipses that Donald Liebenberg has witnessed in person. *Image courtesy of eclipse-chasers.com*

narrow shadow. My flight aboard a Concorde supersonic jetliner allowed me to remain within totality for seventy-four minutes. That alone is the equivalent of more than twenty-five total solar eclipses, which average about three minutes of totality each.

When the sun's raiment, the white-light corona, appears during totality, I am awed by the coincidence of the same angular size of the sun and obscuring moon. The white-light veil further hides many emission lines from ions in the corona that my instruments are able to bring out and place on film or as digits stored on tape.

At eclipses that occurred more than fifty years ago, I helped determine that energy is added to the corona and that the temperature can increase as the distance from the center of the sun increases. Everywhere else, the sun gets cooler moving outward. This was an important change from earlier models of solar wind.

Liebenberg

And forty-four years ago, I found evidence for a five-minute oscillation in the corona that had been discovered a few years earlier in the solar photosphere. This suggested a connected mechanism for putting energy into the corona. More recently, I've found evidence for an eighteen-second oscillation in the FeXIV emission line from the corona.

We now know from many observations by others that various oscillations are observed in the corona from a variety of waves, many related to the magnetic fields that strongly influence and guide the plasma of ions and electrons of the corona. Yet, there is more research to be done because large storms of coronal mass ejections have become known as potential dangers for satellites, space-station occupants, and terrestrial power grids. A better understanding and an ability to predict these mass ejections remain essential parts of solar research.

How do I sum up my more than two and a half hours spent in the totality of solar eclipses?

SPECTACULAR … a magnificent view of the solar corona that we observe as the lunar shadow reaches the Earth.

EXCITING … to observe the white light and emission-line corona that challenges our understanding of the energy source to produce this ethereal plasma.

GRATEFUL … for the many people who have helped make my observations possible and provided the stage for their discussion.

Perhaps a rhyme—in the mode of R. L. Stevenson—is the best way I can provide closure for this twenty-seventh eclipse:

ECLIPSE SHADOW

I see a lunar shadow and corona in the sky
　　The use of it I do not know but do keep asking why
It travels very fast, coming from the West
　　And it races on ahead like a very startled guest.
I glance up to the sky with corona shining bright
　　But too soon the shadow's gone and with it goes the night
The air has cooled and birds are settled in their nest
　　Thinking that the early sunset would give them greater rest
As the shadow travels East and the sky gains further light
　　I know that I have seen a most ethereal sight.

—Donald Liebenberg, 2017

FIFTEEN MINUTES OF FAME—AND THEN SOME!

Dr. Donald Liebenberg's lifelong exploits attracted local, national and even international attention during the weeks leading up to the August 21, 2017 total solar eclipse.

The Clemson University scientist conducted about twenty interviews with media broadcast and print outlets ranging from Seneca, South Carolina, to Washington, D.C., to around the globe. Stories about him appeared in hundreds of media venues.

Here are a few highlights:

- *The Atlantic*: http://theatln.tc/2vyGeEE
- NBC's Mach: http://nbcnews.to/2sF8q3H
- The Associated Press: http://bit.ly/2wuhdYf
- C-SPAN: http://cs.pn/2wqwMSz
- NPR: http://n.pr/2vKjv7W
- *USA Today*: https://usat.ly/2vyn7Kw
- FRANCE 24: http://bit.ly/2vRmw2d

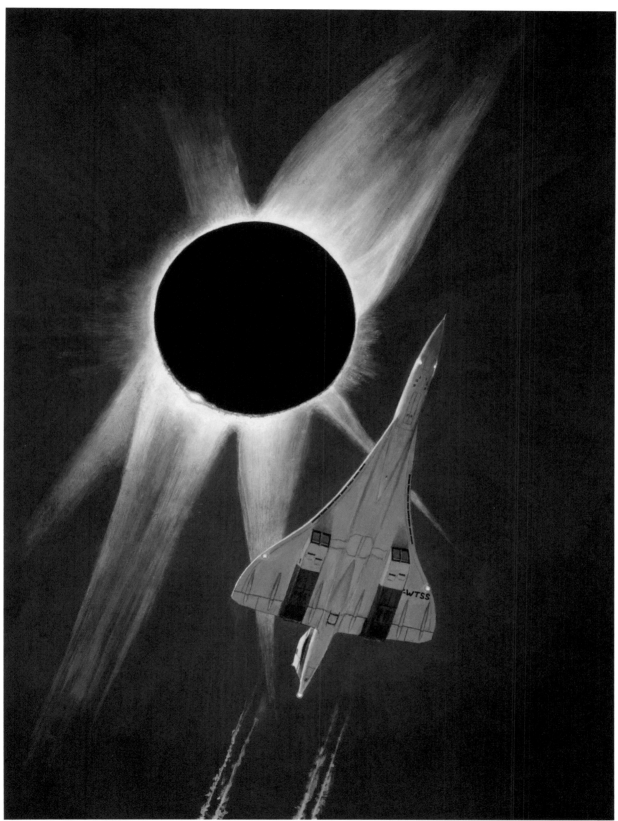

Racing the Moon © 2005

QUOTES FROM THE CROWD TAKE 3

CLOCKWISE FROM TOP RIGHT: *"My sister lives in Charlotte, and I don't get to see her very often. I'm up in Vermont, and I came down to visit her and then we picked a spot that was going to be right under the path of totality. We thought this would be a great venue for us. We're definitely going to try to see the one seven years from now, though the weather in Vermont isn't as good as it is down here."* —James Robb, Brattleboro, Vermont ● *"I am so impressed. I cannot describe it. I was concentrated in totality, and I was impressed by how darkness came suddenly. For me, it was unbelievable."* —Susana Vilela, Fayetteville, Georgia; *"The corona around the moon was breathtaking."* —Marcelo Quinones (right), with son Marcelo Quinones-Vilela. ● *"We chose Clemson because it's on the direct line of totality. I don't know nearly as much as my dad, but I know the eclipse is going to be really cool. I've never seen an eclipse before. I hope it goes really dark. We're probably going to see a lot of other planets, especially Jupiter and Venus. And of course, the eclipse, because it's the eclipse."* —Jack-Hyatt Rosenburg, Roswell, Georgia; *"We've been planning this for two years. We booked the hotel ages ago, and the fact that it's at a university like Clemson—it's just where we wanted to be. We're Clemson fans. Go Tigers!"* — Devora Rosenburg, Roswell, Georgia ● *"I feel amazed and blessed and very excited that I've actually seen the eclipse. I wanted to see totality and the diamond ring effect the most."* —Alexandra Tiborczszeghi, Sugar Hill, Georgia

CLOCKWISE FROM TOP LEFT: *"Clemson is so close to our hearts because my sister-in-law went here about twenty years ago, so we always root for the Tigers. We heard about the big celebration here, and being able to watch the eclipse on the monitors, and that made us come all the way down."* —Geetha Venkataraman, Cary, North Carolina ● *"We chose to come here today with our homeschool friends to see the eclipse, be in the crowd, and take it in because it's a once-in-a-lifetime opportunity. It was breathtaking. I actually cried. It was so amazing. I just think the Creator who created us all is amazing. So, it was definitely a spiritual experience for me. I saw an eclipse when I was nine, but this will be the one that I will remember for the rest of my life."* —Crystal McAtee, Easley, South Carolina ● *"Dad and I chose Clemson because it was really close to the path of totality and we like your football team. This is my third eclipse and his fifth eclipse. I think it is just such a unique experience to be able to have when you're on the face of this planet. It's that tingly feeling every time."* —Catherine Harvey, Concord, North Carolina; *"It was almost like being born again. Standing there during totality, it's like you're watching the solar system form. It's just like magic; it's unlike anything else you can do on this planet."* —Roger Harvey, Concord, North Carolina ● *"We just dropped my son off on Friday, so we drove back up to watch this with him. I had never seen a total eclipse before, and oh, was it awesome. Like Rick Brown said, 'why wouldn't you drive a few extra miles and see the whole thing?' My friends back in Atlanta are saying it's really cool, but when it goes completely dark, that's the coolest. It's hard to describe in words what it felt to be in complete dark in the middle of the day like that."* —Samantha Holt, Marietta, Georgia

Dr. Dieter Hartmann celebrated the eclipse with an appropriate choice of beverage. *Photo by Dieter Hartmann*

THE ECLIPSE, MY FAMILY, AND ME

DR. DIETER H. HARTMANN
PROFESSOR, DEPARTMENT OF PHYSICS AND ASTRONOMY

Months ago, I chose to watch the eclipse from my own back yard. As it turned out, it was a decision I'll never regret.

PREDICTING AN ECLIPSE WITH HIGH ACCURACY IS ONE OF THE most beautiful demonstrations of the power of science.

On August 21, 2017, the "Great American Eclipse" crossed the continental United States on a long path from the northwest to the southeast. My high-energy astrophysics colleagues had long since settled on a site along this path—Sun Valley, Idaho—to hold one of our regular meetings in conjunction with this event. I was tempted to be there, but I decided not to attend the meeting, even though it was going to highlight exciting new results from several satellites.

Why didn't I go? Well, it turned out that the path of the moon's shadow was going to pass right over Clemson. If Nature arranged for a total solar eclipse over my house, it seemed crazy to leave home to witness this spectacular natural phenomenon somewhere else. However, the clouds needed to cooperate, and the outlook for Clemson was okay—but not as good as it was for

several other places along the path of totality.

Regardless, I was willing to take the risk. If it worked out, I would witness the eclipse with my family from my own back yard. My wife Jenny Rizo-Patron agreed with my decision—and hence, it was settled.

Monday, August 21 at 14:37:10 EDT, early afternoon, was the exact time for the onset of totality at our location. The sun would be nearly overhead. Thanks to science, one could decide to work until a few minutes earlier, step outside briefly to watch, and then go right back to work afterward. Just kidding. This was indeed a rare, glorious total eclipse, the perfect alignment of sun and moon, revealing the solar corona as the high point of such an event. But the partial eclipse before and after totality was also not to be missed. This event would be much more than a brief flash of super-spectacularity.

We knew of the event many years in advance, but to me

it became real only during the summer of 2017 when I joined Clemson University's staff and faculty in helping prepare the campus's mega-viewing party. There was so much to think about, from the guessing game of just how many people would come to Clemson, to organizing the distribution of certified solar shades. Our team worried that people might hurt themselves by viewing the sun improperly. Also, we debated where to base our viewing party and how much water and food we would need, as well as vitally important necessities such as public toilets and first aid. We also had to decide how best to arrange and assist an unprecedented gathering of local, national, and international print and broadcast media.

Jim Melvin, Dr. Amber Porter, Dr. Mark Leising, and others who carried the burden of organizing our ever-expanding event share their stories of this labor of love elsewhere in this book.

Obsessively worried about the weather during the weeks leading up to the eclipse, I went every day at about 2:30 p.m. to the same place on the Lake Hartwell dike near the Madren Center. One week before the eclipse, it was way too cloudy for my comfort. Then, an afternoon cloud pattern settled in that looked okay—but it always had some clouds moving through the area near the zenith, where the sun would be. The Friday before the eclipse, I was at my spot exactly at eclipse time, and the sun was totally covered by exactly one cloud. OMG, what if this happened on Monday, Eclipse Day? The cloud moved fast enough to clear my view in less than two minutes, so perhaps not all would be lost, even with clouds. But it was clearly a gamble, and my anxiety levels were rising. On Sunday, the day before the eclipse, The Weather Channel predicted good conditions, but it still turned out to be significantly cloudy that day.

On Eclipse Day, I spent several hours on campus with tens of thousands of eclipse fans, watching amateur astronomers tinkering with their telescopes and cheering on our students who had set up many booths to interact with the public. It was hot and humid, and I was wearing a black eclipse T-shirt. I eventually left campus and went home to where my family had gathered.

We were joined by friends of our kids, and also by Laura Cadonati from the Georgia Institute of Technology in Atlanta and her friend Peter Couvares. They came with their bunch of lovely kids. My grandson Lucas had a great time playing with them.

As the moon started to take bites out of the solar disk, we put on our special solar shades every so often and argued about the percentage covered by the bites. As we neared totality, our excitement mounted along with the now rapidly changing light levels of the sky, and we were all swept up by the imminence of totality. The clouds that were there just minutes before were kind enough to move out of the way, and we all dropped our jaws and oohed and aahed when the diamond ring appeared.

It blew our minds. None of the information we had collected prior to the event had prepared us for the real deal. It was

Hartmann's family joined him on Eclipse Day. *Photo by Dieter Hartmann*

amazing, beautiful, stunning, spectacular. I was so happy that I had decided to experience the eclipse at home. And I was also glad that I had witnessed my first total solar eclipse with my family, friends, their kids, and especially with my grandson, who—in his own words—had already been around the sun five times. Even the mailman stopped at our house to join our viewing party.

We used pinhole cameras. My daughter took images with a properly filtered camera, and iPhones provided social cover. But best of all, we used our natural senses to absorb the highlights. We listened to the animals, viewed the strange colors of the semi-dark sky, and gazed in wonder at the corona.

Afterward, I celebrated (appropriately) with a cold bottle of Corona. As an astrophysicist, I felt compelled to explain to anyone willing to listen that the real corona is a multimillion-degree plasma surrounding the sun, generating the white light we see by scattering the sun's photospheric emission of electrons. I explained that we can see the corona only because the moon currently has the right distance to perfectly cover the sun, and that the sky is dark enough when we are inside the shadow of the moon.

I shared that the reason for the high temperature of the corona is still an open debate in solar physics, and I touched on many scientific issues related to the sun and moon and how they matter to us on Earth.

These stories are all interesting, but what remains from Eclipse Day is the memory of how I felt when our gathering screamed for joy during totality. The two and a half minutes passed far too quickly, but the memories will remain for the rest of my life.

Millions of eclipse enthusiasts along the path of the "Great American Eclipse" likely feel the same. And perhaps I will chase the next total solar eclipse in some other place in the world, as one will surely not appear again in the sky above Clemson while I'm still walking the Earth.

After obsessively watching the weather leading up to Eclipse Day, Hartmann was pleased that August 21 dawned bright and clear and remained that way throughout most of the day. *Photo by Dieter Hartmann*

DR. DIETER H. HARTMANN is a professor of astrophysics in the Department of Physics and Astronomy. He holds a Ph.D. from the University of California-Santa Cruz (UCSC, 1989). After studying Engineering in Lübeck and astrophysics at the Gauss Observatory in Göttingen, a Fulbright stipend enabled him to study at UCSC, where his research interest turned to gamma ray bursts (GRBs). At Lick Observatory, he searched for their optical counterparts and investigated radiation transport in neutron star magnetospheres. After his Ph.D., he held a postdoctoral research position at the Lawrence Livermore National Laboratory. In 1991, he joined Clemson University to pursue nuclear and γ-ray astrophysics. He serves the astrophysics community as a Scientific Editor of The Astrophysical Journal and a member of the Astronomy and Astrophysics Advisory Committee (AAAC). His current research lies in the area of time domain astrophysics, which explores explosive phenomena such as novae, supernovae and GRBs.

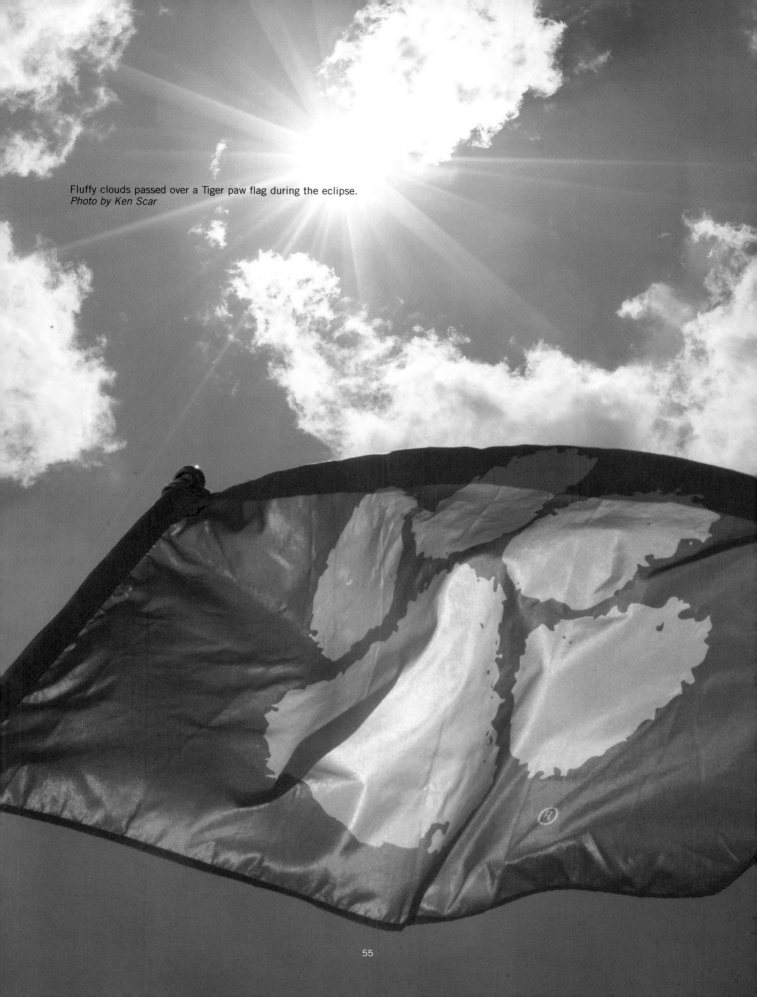

Fluffy clouds passed over a Tiger paw flag during the eclipse.
Photo by Ken Scar

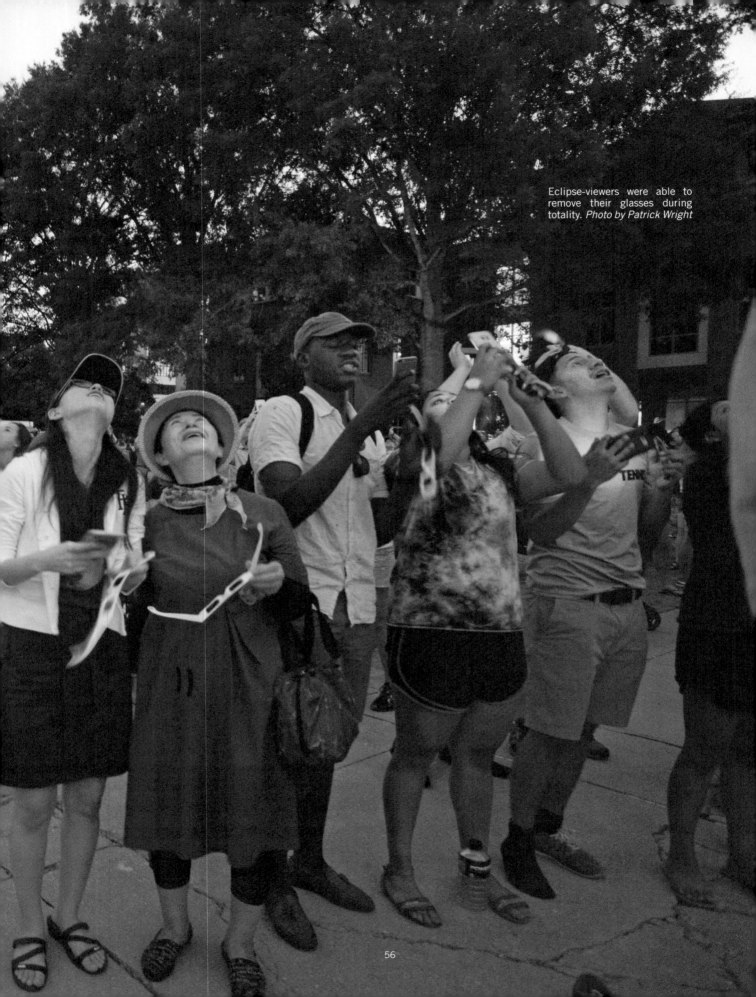

Eclipse-viewers were able to remove their glasses during totality. *Photo by Patrick Wright*

This was a view of the sun about a third of the way into first contact. *Photo by Craig Mahaffey*

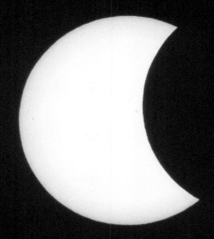

The magical moment of totality was stunning in the sky over Clemson. *Photo by Pete Martin*

The sun cast a startling array of light just after totality.
Photo by Ken Scar

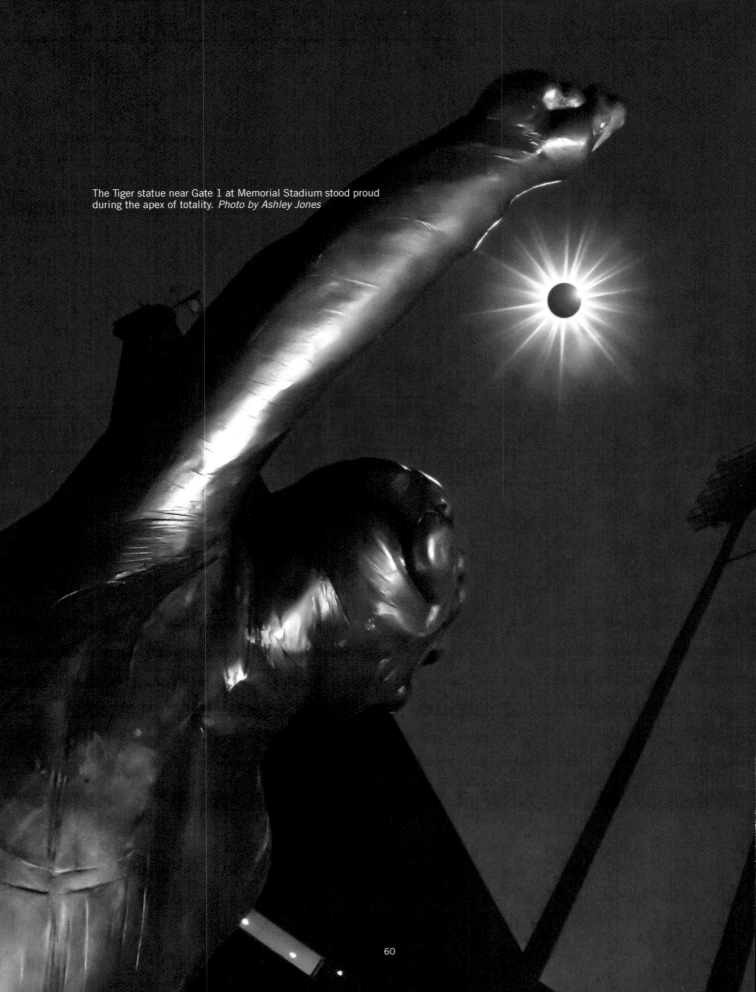

The Tiger statue near Gate 1 at Memorial Stadium stood proud during the apex of totality. *Photo by Ashley Jones*

Botanical Garden director Patrick McMillan watched the eclipse from the expansive grounds of the garden. *Photo by Edward Pivorun*

A NATURAL RESPONSE

DR. PATRICK D. MCMILLAN
PROFESSOR, DEPARTMENT OF FORESTRY AND ENVIRONMENTAL CONSERVATION

The experience of totality caused the humans among us to open our eyes wide with wonder. But the darkness was too brief to have an obvious effect on the plants and animals.

The plants, animals and insects at the Botanical Garden appeared to pay little heed to the eclipse. *Photo by Ashley Jones*

TOTAL SOLAR ECLIPSES HAVE BEEN KNOWN TO ALTER THE COURSE of human history. They were seen as omens of bad times or good, and even led to the changing of kings. In 585 BC, a 15-year war between the Medes and Lydians in ancient Asia came to a sudden end because of an eclipse. So, it would make sense that something so important to us would also have a profound impact on nature.

At least that's what you'd think, right? If you happen to be a well-known naturalist in the path of totality, odds are you've been bombarded with calls and requests from the public and the media about "nature's response" to the eclipse. If you're on social media, you've probably read reports about spiders beginning and then removing their webs, katydids starting their chorus, bats flying about, and even night-flowering or night-closing flowers responding during the brief darkness. On August 21, 2017, I sat perfectly positioned at the South Carolina Botanical Garden awaiting the response and documenting it all with video and photographs before, during, and after.

The day began here in the garden much the same as any summer day: grasshoppers, day-singing crickets, and cicadas singing loudly, the occasional chirp of a squirrel tree frog, hummingbirds swarming the feeders, and butterflies flitting about everywhere. Every sense is met with movement and life here at all times of day. The incredible spectacle that unfolded in the sky at 2:37 p.m. and lasted for two minutes and thirty-seven seconds was met with incredible applause and gasps by the thousands of visitors that assembled here at the garden.

The response of nature was imperceptible—except that it was dark. Cicadas continued to sing, grasshoppers rang forth as though nothing had happened, and butterflies paused on the flowers they were visiting. Much as the bees that were visiting the Gomphrena plants by my feet did at the time, even the hummingbirds kept feeding, one after the other. There was no emergence of bats, no chorus of katydids or frogs, no flowers were tricked into thinking it was night. Though there were no spiders near me, I suspect their response was similar. This was exactly what I suspected before the eclipse and it bore true for those brief moments of darkness. The question then becomes simple: Why?

Flowers such as the truly night-flowering evening primrose and morning glories, and plants that move their leaves by drooping and closing their leaflets such as acacias and sensitive plants, do respond to darkness. The period of darkness is the trigger that elicits their response. Why the event of totality had no impact is largely due to the length of darkness required for these plants to respond; two minutes and thirty-seven seconds is simply not long enough. Most of these plants don't open at dusk. Those that flower at night are generally pollinated by moths and many don't open for several hours after dusk. If you stroll through the desert garden an hour after dark, you won't see leaves folded, or the flowers of evening primrose or jimson weed open wide. You have to return two or three hours later to see the full impact of darkness.

Similarly, the drop in temperature that happens in some

locations with very low humidity and cloud cover, such as occurs in desert regions, wasn't experienced here. A degree drop from ninety-one degrees Fahrenheit to ninety degrees Fahrenheit was recorded at our weather station.

The animal response was probably similar to ours: Wow! They then went about their business. I have seen many strange and unexpected responses in this world concerning circadian rhythms, that is the daily schedule kept by nature. I was quite surprised that the activity of birds and mammals was highest between 6 and 9 a.m. in Barrow, Alaska, during the summer when the sun never sets. Though the light level is strong all day, these animals still keep to their dawn and dusk activity schedules as if the sun had set. The fact that nature wasn't caught off guard, that it wasn't fooled into thinking night had come, doesn't lessen the impact of this incredible celestial event.

My crew, my family, and I watched in amazement as the light penetrating the shadows of trees and even the through petals of Gaillardia became crescents, mimicking the image of the partially covered sun above. This effect is essentially the same one that I used to "see" the eclipse that I experienced in 1979. We poked a hole in a cardboard box and watched the sliver of sun go from a sphere to a crescent and then back again. Every slender space through which light is forced created this image and shaped the dimly lit world in a spackling of crescents! The final moments before totality, a single sheet of white paper suddenly danced with the moiré effect of alternating and moving dark and light stripes created by the sun's rays racing through the valleys and craters of the moon itself.

The moments before totality it appeared as though the cloud cover might impede our view of the true spectacle that so many had journeyed here to witness; but then, just before totality, the clouds diminished before our eyes and the full glory of an event of a lifetime was met with cheers! That is what I believe is the true magic, the true response of nature: the jaws dropped; the eyes wide; the gasp as something we will likely never see again meets our eyes and enters our memories, never to be erased. Hopefully for those moments you, like me, spent more time sharing the sheer emotion and awe with your family than looking for strange responses in nature.

DR. PATRICK D. MCMILLAN is the Emmy Award-winning host, co-creator, and writer of the popular ETV nature program *Expeditions with Patrick McMillan*. For more than twenty years, McMillan has worked as a professional naturalist, biologist, and educator. His range of experience has concentrated on botany, though he is also well-respected through his work in ichthyology, herpetology, and mammalogy. McMillan is a professional naturalist, the Glenn and Heather Hilliard Professor of Environmental Sustainability, a faculty member in the Department of Forestry and Environmental Conservation, the director of the South Carolina Botanical Garden, the Bob Campbell Geology Museum, and the Clemson Experimental Forest, and an honorary member of the Clemson University Class of 1939. McMillan received his Bachelor of Science in Biology from the University of North Carolina, Chapel Hill, and his Ph.D. in Biological Sciences from Clemson University. His research has been featured in both *National Wildlife* and *South Carolina Wildlife* magazines, as well as in numerous articles in *The State*, the *Greenville News*, and other local and regional newspapers. In addition to hosting *Expeditions*, McMillan spends his time at Clemson University fulfilling his teaching, outreach, and curatorial duties. He is an active member of several organizations, including the South Carolina Association of Naturalists, the Southern Appalachian Botanical Society, the South Carolina Native Plant Society, and the South Carolina Entomological Society.

QUOTES FROM THE CROWD TAKE 4

CLOCKWISE FROM TOP LEFT: *"Growing up, I was probably eight or ten when we had a total solar eclipse in India, but we were forbidden to go out, see, or do anything because we didn't have the glasses back then. Today, I just thought I'd drive down with my dog to witness this."* —Satya Kallepalli, Carrboro, North Carolina ● *"I came to Clemson to watch the eclipse because I have been wanting to see a full, total eclipse for some time. It's a nine-hour drive from where we live. We were drawn by the speakers, and Rick Brown, who was fabulous."* —Stephany Crane (left) with husband Roger, Arnold, Maryland; *"I flew into Atlanta, then drove up to Clemson, and we met last night. We'll be here for a couple of days and we're really excited. Yesterday we took a tour of the campus, canvassing things out, and the campus is absolutely gorgeous. I know we'll be back again."* —Sharon Siegel, Fort Lauderdale, Florida ● *"We looked at the map of the eclipse and headed south. The last time I saw a total eclipse, I was on a beach with less people. That was March 1970. My daughter was two months short of being born. We drove all night and slept on the beach; this time we opted for a hotel."* —Alan Rolnick, Woodmere, New York ● *"We drove down yesterday, and we chose to come to Clemson because it sounded like you guys were having the best event in the area – putting a lot of work into having vendors, food, drinks, things like that – so we thought it would be cool to come down here and be able to watch it with a lot of people all at once."* —Dennis Bates, Arlington, Virginia

CLOCKWISE FROM TOP LEFT: *"One of my very good friends, who I graduated with in Food Science in May of this past year, is a grad student at Clemson now. I had shared something on her Facebook about how Clemson would be right in the middle of the path of totality, and she said, 'Well, you should just come.' Two weeks ago, I didn't have eclipse plans, and now I'm here."* —Eleanor Frederick, Raleigh, North Carolina ● *"Clemson was the closest university to us that was in the path of totality. I've seen a partial eclipse before, but I was in middle school and I don't have much memory of it. This one was amazing. It is a beautiful phenomenon. One thing that made it more interesting was being with all the people here. Everybody was excited to be here. It was an emotional moment."* —Kayvan Tehrani, Athens, Georgia ● *"We came from Concord because I wanted to show my kids a once-in-a-lifetime opportunity. We're here, we're nearby, so we left our house at 5 a.m. to drive down here."* —Christina Alvarez, Concord, North Carolina; *"I heard that animals might go back in their dens and go back to sleep. But I think the actual totality, and also seeing how plants and animals react, will be coolest."* – Mia Alvarez, Concord, North Carolina ● *"We've been through a lot of recession years in our business, and we're emerging from that but it's been a tough ten years. The political world is totally screwy, and we are sixty-four years old, which is kind of on the brink of what we hope is a positive part of our lives. It seems like this kind of event is a herald in better times. We're washing away the tough stuff and opening doors to a new perspective."* —Rebecca Carnes, Chapel Hill, North Carolina; *"I thought it was a renewing experience. We're going through some changes in our lives that line up with this eclipse. We came down looking for a spiritual experience, and I feel like I had that. This was a lot of people coming together for a common experience, and that can be replicated in dealing with resistance and what needs to happen now to push back against what is happening politically."* —Dann Carnes, Chapel Hill, North Carolina

Dr. Sean Brittain researched the eclipse from the rooftop of the Watt Family Innovation Center. *Photo by Craig Mahaffey*

A WIN FOR SCIENCE—AND FOR HUMANITY

DR. SEAN BRITTAIN
PROFESSOR, DEPARTMENT OF PHYSICS AND ASTRONOMY

A Clemson astrophysicist's involvement in a nationwide telescope experiment will help pave the way for future discoveries, while also potentially inspiring a new wave of scientists.

ON SEPTEMBER 25, 2015, I RECEIVED AN EMAIL FROM MY COLLEAGUE at the National Optical Astronomy Observatory:

> I heard a lunch talk today about the Citizen CATE experiment for the 2017 solar eclipse. I see that Clemson is very close to the mid-eclipse path. I also noted that Don Walter at SC State is already a major player in Citizen CATE. I wanted to make sure you knew about Citizen CATE ... Send Matt Penn an email (or call) and get on board. Don Walter has some of his people going on an eclipse in Indonesia next year so they can be experts. Clemson can't miss out on this.

My interest was piqued. It was the first I had heard that we would have a total solar eclipse visible from our own backyard. Although I've spent years teaching students about the solar system (and eclipses), I had never seen a total solar eclipse

myself. But more importantly, this was a chance for massive public outreach.

For the most part, the scientific community has failed to make it clear to the public that science is for everyone. One need not be a savant or have the right pedigree to be a productive member of the scientific community. Ours is a technologically advanced society that is deeply dependent on what science can tell us about the world. Solutions to our most pressing problems require creative ways of looking at the world that benefit from a diversity of perspectives. To attract the best and brightest to work on these problems, we must draw from as broad a talent base as possible.

To effectively disseminate the knowledge gained from scientific investigations to a diverse population requires scientific voices that can speak the language of all the populations we have the responsibility to serve. To make informed decisions in a

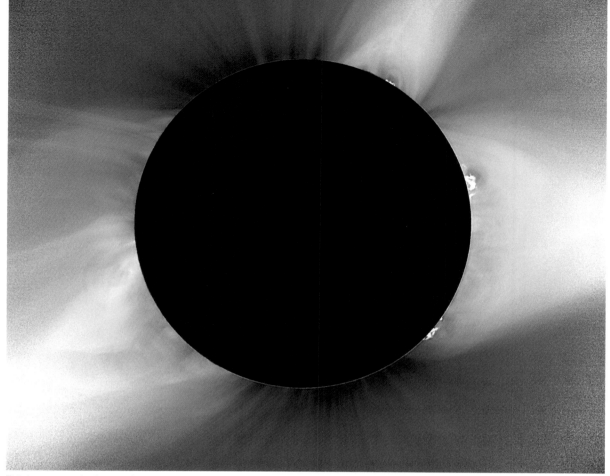

This is a composite image of totality taken via telescope by Brittain in collaboration with the Citizen Cate Experiment. *Photo courtesy of Citizen CATE Experiment 2017 Team*

technologically dependent society, scientific literacy is essential. Furthermore, the study of science is the study of a methodology that is valuable to a wide range of careers not generally thought of as "scientific." In short, learning the methods of science is essential for everyone, and the scientific community has done a woeful job reaching broad swaths of our nation.

Correcting this error is complicated. There is no silver bullet to fix all our deficiencies. One thing we can do is provide opportunities for the public to get involved in the scientific process, and a citizen-science project tied to an eclipse passing over the entire continental United States was something I knew Clemson could not afford to miss.

While total solar eclipses are relatively common—there is one somewhere in the world about every eighteen months—the shadow does not typically spend this much time over a relatively populated area. The August 21, 2017 eclipse passed from near Portland, Oregon to Charleston, South Carolina over a span of about ninety minutes. During this time, the moon blocked the photosphere of the sun, allowing the solar corona to be seen. While coronagraphs exist on solar telescopes, they generally block more than just the photosphere, thereby hiding the innermost portion of the corona. By placing multiple telescopes along the path of totality, solar physicists will be able to study the dynamics of the corona with an astounding ninety minutes of footage.

Such an undertaking does not require particularly sophisticated equipment, but it does require a large number of dedicated observers. Thus, the citizen-science project titled Continental America Telescopic Eclipse (CATE) was born. This project included sixty-eight sites and more than a hundred volunteers. The volunteers came from all walks of life and included school teachers, amateur astronomers, students, professional scientists, and retirees. These sites hosted tens of thousands of people who all had the opportunity to learn more about our sun, eclipses, and the process of doing science.

At our Clemson site, I had the pleasure of working with three students: Erin Thompson, a rising sophomore physics major; Harrison Leiendecker, a rising senior physics major; and Stanley Jensen, a fifth-year Ph.D. student. These three students committed many days and nights through the summer getting trained, practicing with the equipment, and learning to work together. We perched ourselves on the roof of Clemson University's Watt Family Innovation Center, which provided a way for us to broadcast our data all across campus for our visitors to see. On the day of the eclipse, about 50,000 people came to experience totality. It was an exciting day of scientific outreach to our local community, as well as to visitors from literally around the world.

Despite the threat of clouds in the vicinity, the weather cooperated and we were able to record images of the corona

unimpeded by clouds. Much to our collaborative pleasure, fifty-eight out of the sixty-eight Citizen CATE sites across the nation had clear weather and were able to acquire outstanding data.

The data consist of white-light coronal images that will be used for static and dynamic studies of the sun. The closest star in the universe to our planet is the sun. It is the template we use to understand other stars. Sometimes, it is easy to forget just how vast our universe is. If we think of the sun as an object the size of a softball, then Earth would be about the size of a grain of sand.

Using this scale, if our sun were located in Clemson, the next nearest star would be in California. Given how far away all other stars are, we can never study them in the same amount of detail as we study our sun. However, despite its proximity, there is much we do not know about this closest star. For example, questions remain about things as basic as why the temperature of the corona is so much hotter than the temperature of the solar surface. The surface temperature of the sun is about 10,000 degrees, while the temperature of the corona can reach millions of degrees. There are several ideas about how the corona is heated, but we still do not understand this process in detail. The sun also launches plasma into space, and there is still much to learn about what drives this process. Data from the Citizen CATE project will address many open questions about our sun.

For example, the static images will allow us to study polar plumes within 22,000 miles of the surface of the sun. Previous studies have gotten no closer than 70,000 miles. Polar plumes are jets of million-degree plasma extending thirteen million miles into space. The enhanced resolution of the CATE data will enable solar physicists to study the origin of these features of the corona in ever greater detail. While the static measurements are valuable, the ninety minutes of footage provide the unprecedented opportunity to study the dynamics of the solar corona, the dynamics of plumes, the magnetohydrodynamics of hot gas moving upward through prominences, oscillations in the active region of coronal loops, and possibly even a coronal mass ejection. The details of these studies are available on the Citizen CATE website (www.citizencate.org). In short, this work will provide an important complement to data collected in conjunction with other facilities, such as the NASA/European Space Agency Solar & Heliospheric Observatory (SOHO).

Better understanding our own sun is intellectually satisfying. We humans have an innate curiosity about the world around us and how it works—indeed, asking "how?" is part of what makes us human. Science has proven itself to be the most reliable process for answering the question of "how" the world works. Understanding how the sun does what it does will also allow us to address more pedestrian—though no less important—issues such as predictions of space weather. But as important as understanding space weather might be for our economy and national security, and as intellectually satisfying a better understanding of our sun might be, I wonder if the most important outcome of this project is the number of people who have been given an opportunity to engage in scientific research who might otherwise have not been involved. Or perhaps it is the tens of thousands who had a chance to see Citizen CATE teams in action—and the young people inspired to pursue scientific studies as college students sometime in the future.

The two years between learning about this project and finally collecting the data flew by. Now, we are looking forward to the next total solar eclipse passing over the continental United States in April 2024. This eclipse will pass over some extremely large metropolitan areas, such as Dallas, Texas; Indianapolis, Indiana; Cleveland, Ohio; and Syracuse, New York. It's likely that an even larger number of people will have the opportunity to experience a total solar eclipse firsthand. Hopefully, there will be other citizen science projects available to engage our communities and communicate the message that science matters to everyone—and that anyone can participate.

DR. SEAN BRITTAIN is a professor in the Department of Physics and Astronomy. He holds a Ph.D. from the University of Notre Dame (2004), where he studied the formation of stars and planets. After completing his Ph.D., Brittain was a Michelson Science Postdoctoral Fellow at the National Optical Astronomy Observatory in Tucson, Arizona, where his research focused on the study of planet-forming disks around young stars. He is currently working to identify forming gas giant planets and connect the initial conditions of planet formation to the dizzying array of planets observed around mature stars. To accomplish this work, he uses telescopes in Hawaii, Arizona, Chile, and outer space to study the birthplace of planets. In addition to research, he greatly enjoys teaching and talking about science with the public. Brittain is particularly passionate about working with K–12 teachers to translate cutting-edge research in physics and astronomy to materials teachers can present in the classroom.

Telescopes using special filters were a popular item on campus that day. *Photo by Pete Martin*

Mandy Gaither (kneeling) of Upstate South Carolina's WYFF News 4 was one of dozens of media personalities at the event.
Photo by Patrick Wright

Telescopes came in a variety of shapes and sizes.
Photo by Heidi Heilbrunn

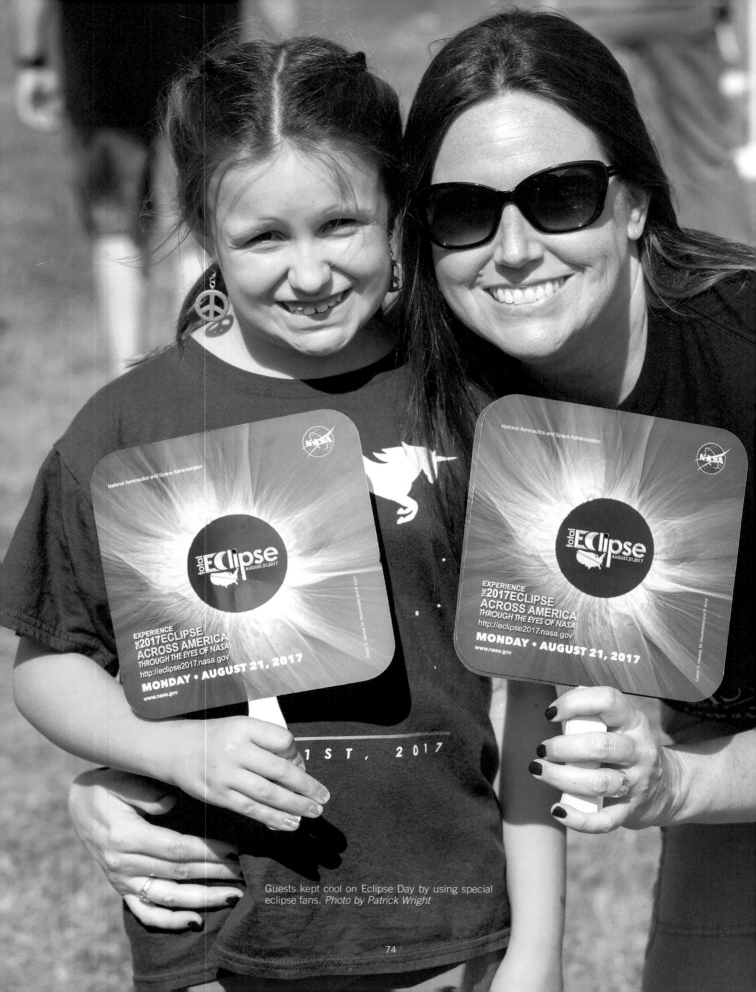

Guests kept cool on Eclipse Day by using special eclipse fans. *Photo by Patrick Wright*

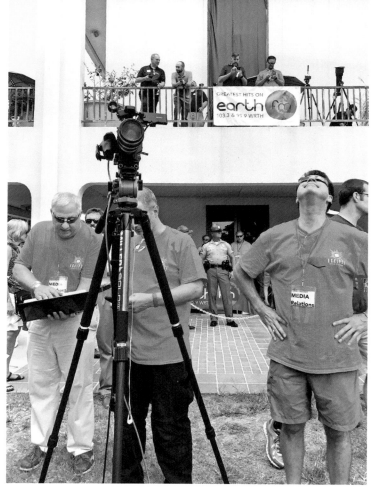

Clinton Colmenares (right) had his eyes to the sky during "Eclipse Over Clemson."
Photo by Tara Romanella

MAGIC OF THE MOMENT INSPIRES
A COSMIC FLASHBACK

CLINTON COLMENARES
DIRECTOR OF RESEARCH COMMUNICATIONS, UNIVERSITY RELATIONS

The eclipse over Clemson revives a lifelong fascination with the sky, the stars and the universe.

I WATCHED THE TOTAL SOLAR ECLIPSE OF 2017 FROM THE CLEMSON campus, behind the Cooper Library and beside the Watt Family Innovation Center, on a patch of grass with about 20,000 other people jammed nearby. I stood between Sherri Walker, a good friend of mine who had driven down from Charlotte, North Carolina, and Rick Griebno, an amazing Clemson videographer. With a microphone in hand, I narrated the stellar spectacle for a live Facebook audience, trying not to sound like a dork.

But the experience took me beyond the two and a half minutes of totality, beyond the hot, exhausting, and exhilarating day, through years of wonder about the sky and the space far above that I share with everyone on Earth.

I was born in Houston, Texas. Known as Space City, USA, it is the home of the astronauts—true American heroes—and

their namesake Houston Astros, with their then-original, space-age Astrodome. As a small boy, I dreamed of playing big league baseball. I loved the Astros, and going to the Astrodome to watch José Cruz gallop across left field, and watching the giant scoreboard light up with rockets and starbursts when a home run flew over the outfield wall. Astronauts and the space program gave my hometown an identity that raised it above its blue collar, wildcat roots and set it apart from Dallas, the gleaming city to the north that most often won the country's attention.

I was just nine months old in July 1969, when NASA sent Neil Armstrong, Buzz Aldrin, and Michael Collins to the moon, but I would come to treasure a personal reminder of that time. My grandfather was an artist for the Houston Post. He created the cover for the newspaper's special moon landing section, a

Colmenares seemed fascinated by the stars almost from the day he was born. *Photo courtesy of Clinton Colmenares*

drawing of the moonscape with the Eagle Lunar Module planted solidly on the moon's surface and Earth floating in the distance, a big blue marble with swirling white clouds.

I came across the original proof of the art when I was in my twenties. I had it framed and proudly hung it in my house and in my office for twenty years, until I lost it during a move. My grandfather died when I was ten, so I couldn't ask him about the piece. *The Houston Post* was bought and abruptly closed in the '90s, so there was no morgue, no library or archive that held a copy of the artwork. I called a city librarian, who couldn't find the piece in their stacks. My grandfather's artwork was dated August 10, 1969. The date didn't mean anything to me, but the librarian told me that was the weekend of the Manson-directed murders of Sharon Tate and others. She speculated that the paper pulled the special section. Or, maybe it was a mockup of an idea that editors decided against. Whatever the reason, I miss that moonscape, almost as much as I miss my grandfather.

Despite Houston's vast expanse of concrete, the city could be claustrophobic. So, after her divorce from my father, my mother purchased land in West Texas, in a little place called Terlingua that was best known for its annual chili cookoff in a nearby ghost town. My mother would load us up—me, my brother, and often our cousins—in the back of her 1970 Chevy pickup, with a camper, and drive all night, some 650 miles from one corner of the state to another. Terlingua is tucked between Big Bend National Park and Big Bend State Ranch, where the Rio Grande makes its characteristic dip.

It seems that most of the world, outside of Texas, thinks the whole state looks like Terlingua—desert, buttes, cactus, rocky outcrops, adobe buildings, and tumbleweeds. To paraphrase an old saying, there's nothing between Terlingua and the North Star but a barbed wire fence. We stayed at a dude ranch, only there weren't many dudes and almost zero ranching that I could tell. It was a series of cabins scattered around the rocky hills, with a

clubhouse, restaurant, and swimming pool.

But the sky. The sky was so big, and it was so close there was a comfort to it. During the day, I could see the horizon without a stand of pines blocking the view. The sun was bigger and hotter than in Houston, giving rocks and ledges the chance to cast cooling shadows over horned frogs and black-eared jackrabbits. At night, we had a nearly 180-degree view of the stars. We could lie on our backs and watch constellations spin a story, entering stage right, slowly taking their place on center stage, and exiting stage left.

Back across the state, on the beach in Galveston where we would spend a Saturday or Sunday every now and then, I felt the sun's lashing for the first time. I remember, when I was around five years old, stopping at a gas station on the highway to the beach and looking up at a billboard, where a scruffy little dog tugged on the Coppertone girl's bikini bottom, revealing a pristine tush.

We spent the day in the Galveston Bay surf, stepping over the occasional puddle of oil, running, digging, and playing in the sand. I fell asleep on the hour drive back to our Houston neighborhood, but woke in time for my mother to strip my clothes, place me in the tub and turn on the shower. Apparently, I was covered with sand and needed a bath before bedtime, a fact that I'm sure I protested loudly. I hadn't known it before the moment the water hit my back, but I was sunburned to a crisp. I screamed and flailed my arms, sure that my mother was torturing me, sure I would die a burning, gritty death.

Despite an olive complexion and Mediterranean roots, the sun would burn me many times, including the Saturday before the Great Eclipse as I sat on a pier at Clemson's rowing beach. Through five decades, I have continually taunted the sun, and it has continually won.

When I was seven, my family moved to East Texas, deep into what's called the piney woods. I came to see the sky as a doorway, an attic opening, set above millions of loblolly pine trees that rose up from the sandy soil like a giant wood curtain a hundred feet high. "Behind the Pine Curtain" was a catchy phrase during the Cold War. It prevented broad views and foresight, and insulated anachronistic customs.

On summer nights I would lie in my bed, pressed against a window in our old farmhouse, and watch heat lightning dance through billowing clouds six or seven miles above, thinking about the power and the light each flash created. Low, distant thunder rumbled down from the heavens and rolled across the earth like the log trucks loaded with pulp wood that rambled down the highway in front of our house, headed for the paper mill.

Our house had a fairly steep roof, and I used to climb to the top, maybe twenty to twenty-five feet up. I also climbed the large magnolia tree in our back yard, navigating its limbs, hidden by its leathery leaves, just to be closer to the sky. I didn't know why. Things on the ground weren't so bad, but they were

limiting. Rising to the sky was a challenge, but even the sky wasn't the limit. The higher and higher I got, the larger the attic door appeared. I could imagine opening that door and stepping into space, into an expanse where anything was possible, where darkness met light and I could float forever.

I saw my first shooting star, a meteor, streaking across a dark East Texas sky. I was seventeen, a junior in high school, doing what bored, stupid boys my age did in the '80s: driving the main drag with my best friend, a few Budweisers in me. We had just left our favorite taco place, heading down Timberland Drive toward McDonald's, when a light shot across the sky, above the golden arches, filling my windshield with wonder and fear. I looked at my friend Danny. He had seen it, too. We both were quiet, not sure what we had just witnessed. Was it the end of times? A message from God telling us to go home? We didn't tip another beer that night.

Thirty years later, I've seen scores of meteors, because I've made it a point to look for them. I've gazed at the moon through a telescope with my daughter and wondered what might be happening in the craters and on the crest of the craters. I continue to wonder what's up there, on the moon, on the sun, in the space between and the space far, far away. And what does that space mean to people like me? The solar system, the galaxy, the universe are endless, and full of dark matter, which we don't even understand. It's full of gases and elements we haven't discovered. The sun is the center of our galaxy, but it's a speck in the galaxy we know, a nanospeck in the universe we

don't know. And what does that make us? We are but spectators to a vast, largely unknown cosmos. We are a tiny dot in a giant snow globe much too large to be included in carry-on luggage.

I studied eclipses leading up to the one I would witness, if the clouds allowed. I heard about the life-changing powers of the moon, 400 times smaller than the sun but 400 times closer, how the math meant our satellite would appear to be the same size as the life force of our solar system, how it would block it out, turning day into night, revealing the sun's corona and creating funky shadows on the ground.

Nothing prepared me for what I saw on August 21. An American Indian legend describes an eclipse as a frog swallowing the sun. Sure enough, the moon took one long, slow bite, and when it swallowed, the sun's corona shot out of the frog in all directions, a spectacular white light that sparkled and swirled. The crowd of 20,000 went wild—and 30,000 more across the vastness of Clemson's campus joined the delirious fray. As the frog slowly gave up the sun and the diamond ring appeared, the crowd went wild again, cheering the sun and moon, dancers in a cosmic pas de deux.

The purity and brilliance of the light that shone from around the moon was ethereal. It was whiter than white and almost unbelievably clear. I won't soon forget that image, or standing between Rick and Sherri among the tens of thousands on Clemson's campus. We all stood together, cheering, looking up at a light shining through an attic door.

CLINTON COLMENARES began his career as a science writer working for a medical newspaper in San Antonio. He went on to write for three daily newspapers before leading strategic communications for medical and science news at several universities and medical centers. He is now the director of research communications (or, as he likes to call himself, the chief research storyteller) for Clemson University. Throughout his career, Clinton has reported from operating rooms, science labs, helicopters, and board rooms, but it's always the people that fascinate him most. He has a teenage daughter, Ella, and a cat, Indi, and he wishes he could play guitar.

SPECIAL GUEST PHOTOGRAPHER

VALERIO OSS is a well-known visual effects artist and graphic designer whose work has appeared in numerous feature films, including *Harry Potter and the Deathly Hallows, Part II*. But his greatest passion has always been astronomy and science. A couple of years ago, he became a student at the Astrophysics University of Bologna (Italy)—and since then has been following astronomical events all around the world, taking photos and spreading, where possible, his scientific knowledge. Oss chose to travel from Italy to South Carolina to view the Aug. 21, 2017 total solar eclipse at Clemson University. "Clemson was my target and the show was really amazing!" said Oss, who was born in Trento, Italy.

Oss graciously gave Clemson University Press permission to use this photograph taken from the campus of Clemson University about 30 minutes before totality.

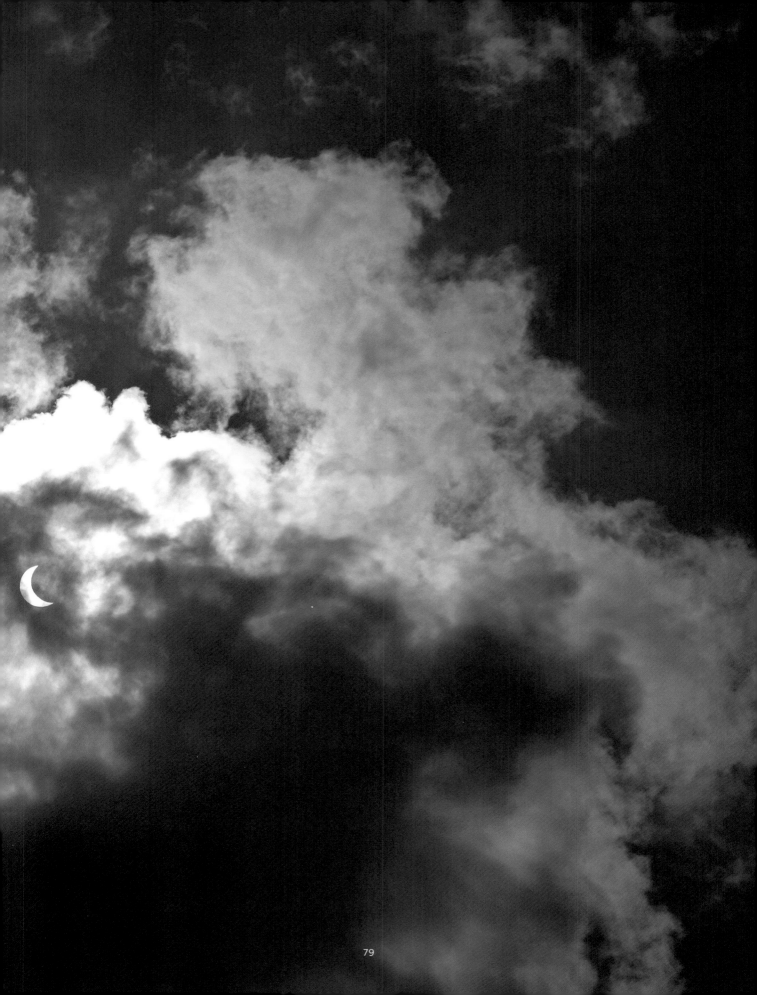

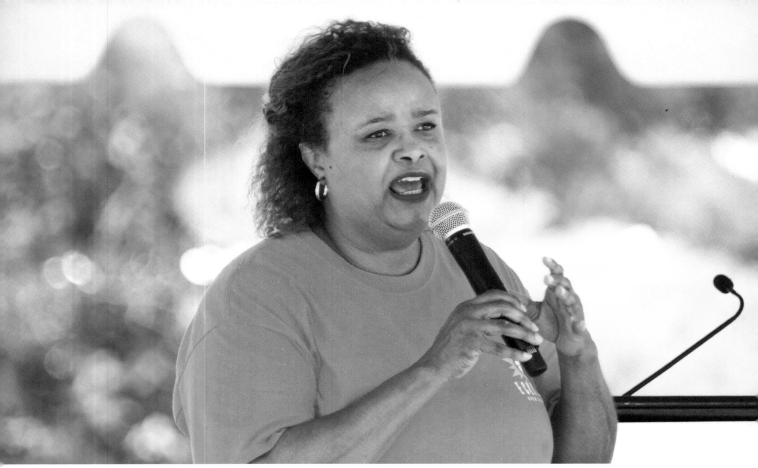

Wanda Johnson-Stokes was a co-emcee on stage during the "Eclipse Over Clemson" event. *Photo by Pete Martin*

GLORIOUS APPEARANCE
WANDA JOHNSON-STOKES
COMMUNICATION STRATEGIST, UNIVERSITY RELATIONS

For a woman of God, the total solar eclipse is a cosmic reaffirmation of the strength of her belief.

SOMETHING SPECIAL IS GOING TO HAPPEN IN A FEW DAYS. THE moon will block the sun and it's going to look like it's night. Don't be afraid. That's what happens when we have an eclipse.

I don't know if these are the exact words my teacher used that March day in 1970, but I know it was something like this.

The Saturday before the August 21, 2017 total solar eclipse, I stood with a group of friends outside the home of one of our classmates. They all remembered hearing our teachers say something similar. I told them I had to leave our gathering to work on Clemson's eclipse mega-party. That's when they all began to recall the day that went dark in 1970. Most of us were around ten years old at the time.

"I remember being afraid to look up," Gwen said.

"I remember glancing at the sun, knowing I wasn't supposed to," Melinda chuckled. "Thank God I didn't go blind!"

"I remember thinking the world was ending," Paul exclaimed.

I suspected Paul got the "world is ending" idea from either a sermon or the Bible. Everyone in the group, myself included, had gone to the same vacation Bible school.

"The sun shall be turned into darkness and the moon into blood before the great and awesome day of the Lord."
(Joel 2:31)

I don't recall being that adept on End Time prophecy, but I'm sure the thought crossed my mind. It was kind of scary back then because most of us only remembered being warned to not look up. No one talked about actually seeing the eclipse. But now that we were older and wiser, we knew how to prepare for it without being afraid. And, everyone was ready to see it!

LIGHTS, CAMERA, ACTION!
Forty-seven years later, I arrived at Clemson to check off things on my eclipse event to-do list. I knew it was important to make

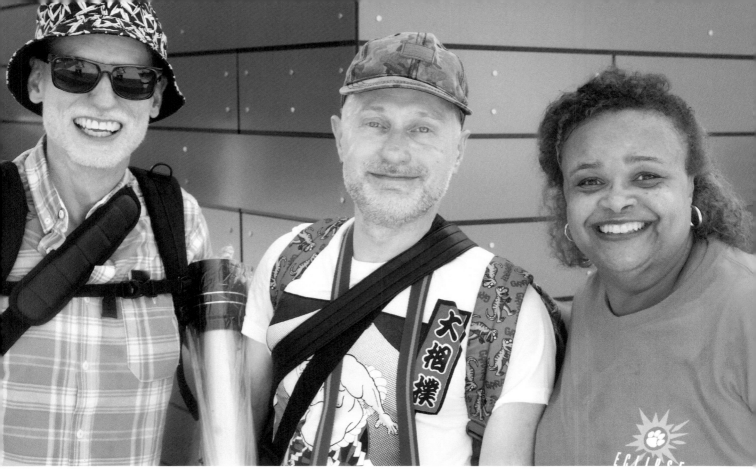

Johnson posed with a pair of guests who had come to Clemson from London. *Photo by Pete Martin*

sure the unprecedented gathering of local, national, and international media had everything it needed for their coverage of the phenomenon.

Two media outlets had parked their trucks Friday, August 18, in the designated spaces next to the Cooper Library. The rest rolled in on Saturday and Sunday.

Correspondents and meteorologists who had promoted Clemson's event in advance with live reports and pre-recorded segments had returned to campus on the day of the eclipse. I ran from one media crew to another:

"Everything cool with you?"

"Yes, looking good," a photographer said.

"Can I get you anything?"

"Naw, we're set to go," a reporter replied.

The magnitude of all our months of planning started to kick in. Media from around the world set up shop on the balcony and breezeway of the Cooper Library to not only get reactions from the public, but to experience the event themselves.

As I worked my way through the line of news and weather crews, it suddenly dawned on me that I needed to get ready—not just to see the eclipse, but to act as co-emcee from the main stage for Clemson's mega-party.

I had had little time to plan what I was going to say as a host, but I took comfort in knowing that Dr. Jerry King was my co-emcee. Our job was to keep the crowd engaged, to introduce speakers, and to make sure everyone knew about all the eclipse-related events taking place on the lawn in front of the Watt Family Innovation Center and at the nearby amphitheater.

DAY OF UNITY

It had to be 200 degrees outside. Okay, that's an exaggeration, but it was pretty hot. Yet, people kept coming. The sweltering heat didn't melt the smiles of the attendees. It just made them glow a little more. Misting stations became a huge hit among children and adults looking for ways to cool down. People took cover under tents, umbrellas, and the canopy of trees facing the Watt Center.

The sea of people coming together for something that would last less than three minutes left me in awe. I thought, "Wow, Lord! This is your hand at work."

The sun alone appears, by virtue of his dignity and power, suited for this motive duty (of moving the planets) and worthy to become the home of God himself.
—Johannes Kepler (1571–1630), German astronomer

Science has always fascinated me. But like Kepler, I don't separate the body of knowledge generated by man from the wisdom of God. For me, only He could use an eclipse to change the headlines dominating the news in the weeks and months leading to the event. Reports of protests, hate, and division went

silent on August 21 as tens of thousands of people congregated at Clemson University for what I dubbed a celestial event. I soon realized it also was a day of unity.

People of most races, nationalities, and religions came together to simply look up. They danced and sang moon- and sun-themed songs, played games, and ventured out to enthusiastically commune with total strangers.

While on stage, I thought it would be cool to see just how far people had traveled to see the "Eclipse Over Clemson," so I did a roll call of all fifty states. I asked folk to shout, scream, and/or applaud when I called the name of their state. From the cheers that arose from the crowd, it appeared that every state – at least to some extent – was represented. And once the roll call ended, a gentleman standing near the front of the stage yelled, "How about Israel?" This prompted another group to scream, "London is here, too."

That's when I knew just how special this day was. People from around the world had come to Clemson for a historic event they would never forget.

THE COUNTDOWN

The hours of waiting dwindled to minutes. Eclipse-chaser Rick Brown talked the crowd through the process, letting everyone know what was about to happen. All I could think of was Rick once stating, "It looks like the eye of God."

The atmosphere started shifting. The crowd's chatter grew fainter. It started getting dark. I stepped off the stage. The moment was coming. We put on our solar shades and looked up. A cloud rolled by and I thought about my colleague, Jim Melvin, and how he had worried for months that it might rain. I kept telling him not to worry because I had connections in high places.

The cloud rolled away. The next thing I remembered was near-total darkness, and Brown describing what we were seeing. I didn't really hear him. All I could do was stare and wait for God's eye.

Suddenly, the moon covered the sun. People started saying all kinds of things, but what I heard most was, "Oh my God!"

I stood next to Clemson University police chief Jami Brothers and said, "Look at God!" President Jim Clements was in front of me. He turned and asked, "What did you say?" I repeated, "Look at God," and he replied, "It is amazing."

Many people talked about the chills the eclipse gave them. Some called it a spiritual experience. I knew in my heart that I felt God smiling on a congregation of people united for His glorious appearance. I also thought of my classmates and why we had gathered that fateful Saturday before the eclipse. We had come together to share condolences for a close friend who had passed away. Seeing that eye gave me comfort as I watched and prayed that our friend's family had also taken a moment to witness the eclipse. I hoped it would serve as assurance that God is always present and watching over us.

WANDA JOHNSON-STOKES is a communication strategist for the Office of Strategic Communications at Clemson University. Wanda's career spans nearly thirty-five years as a television news journalist, radio host, and voiceover announcer. While she served primarily as an executive producer and/or producer for local television stations in both Carolinas, she also worked as a reporter for SCETV and public affairs manager for WCSC-TV in Charleston, South Carolina. Her television news roles also required direct communication with national and international correspondents and producers for CNN, CBS, NBC, and FOX News. Wanda worked as the public information manager for the City of Greenville, South Carolina before joining the Clemson family in 2007.

ECLIPSE OVER CLEMSON
Keepsake Photo Contest Winners

Totality over Tillman Hall.
This contest winner was taken by Robert Seel.

ROBERT M. SEEL, AIA

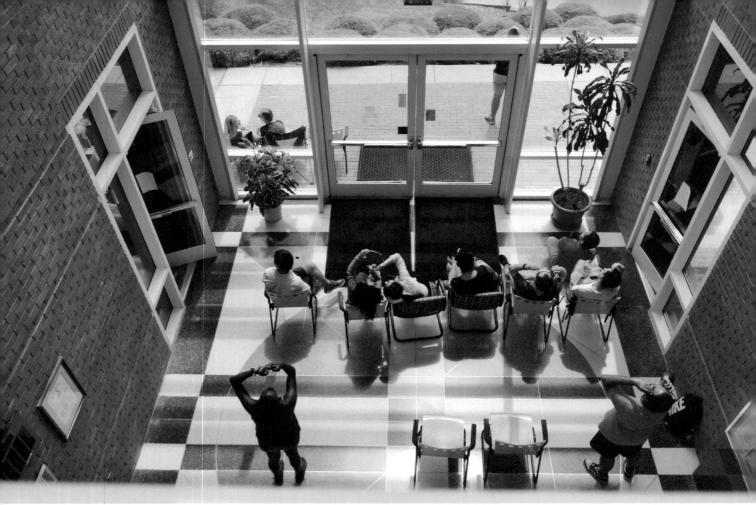

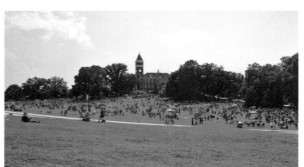

CLOCKWISE FROM TOP: Students witness the eclipse from the rear hall of Fluor Daniel Engineering Innovation Building. *This contest winner was taken by S. Ramaswami*; A view of Boman Field just after the end of totality. *This contest winner was taken by Stan Karmilovich*; The crowd is shown during totality at the main venue. *This contest winner was taken by Jan Comfort*; Chris Porter enjoyed the eclipse from his office in Holtzendorff Hall. *This contest winner was taken by Karen Thompson.*

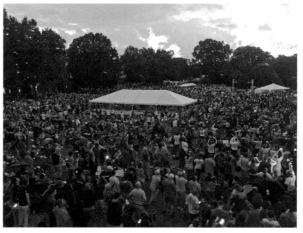

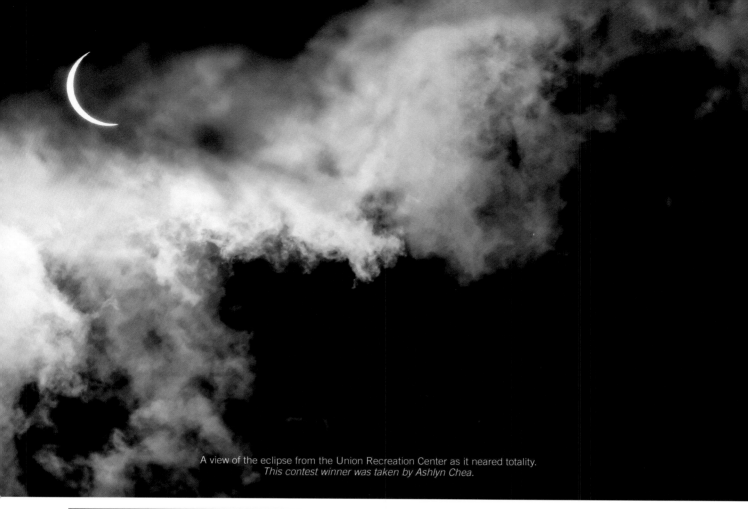

A view of the eclipse from the Union Recreation Center as it neared totality.
This contest winner was taken by Ashlyn Chea.

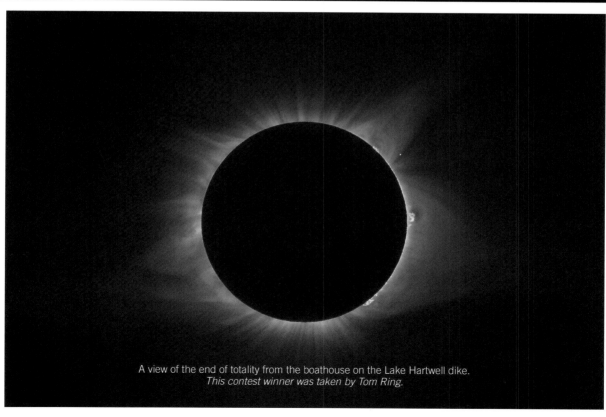

A view of the end of totality from the boathouse on the Lake Hartwell dike.
This contest winner was taken by Tom Ring.

Oak leaves partially covered the occluding sun.
This contest winner was taken by June Pilcher.

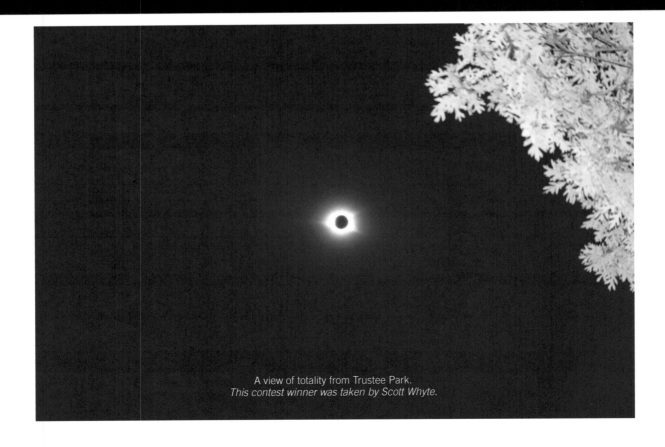

A view of totality from Trustee Park.
This contest winner was taken by Scott Whyte.

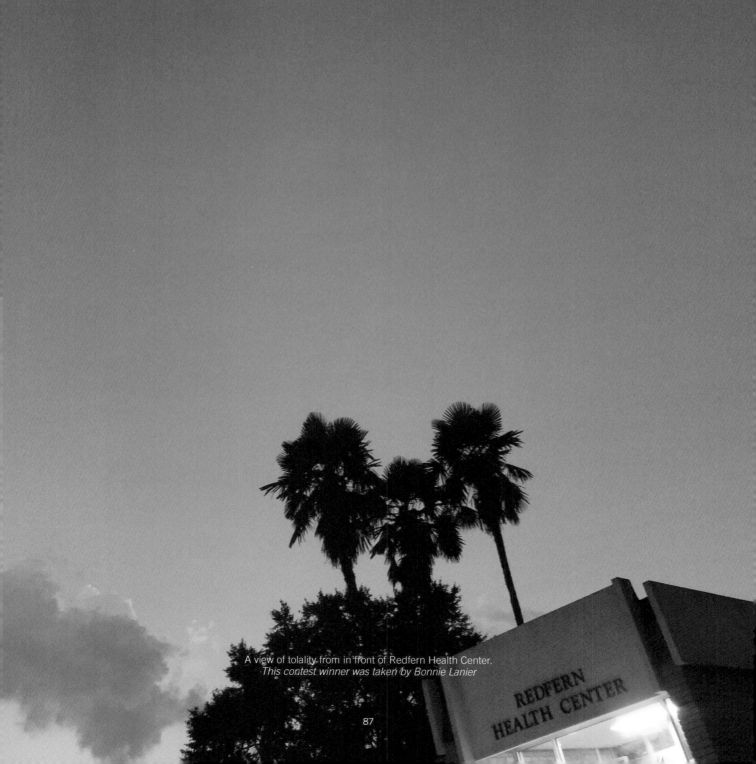

A view of tolality from in front of Redfern Health Center.
This contest winner was taken by Bonnie Lanier

REDFERN
HEALTH CENTER

Nic Brown chose to watch the eclipse from his own front yard. *Photo by Ryan Hoover*

A BIRTHDAY GIFT

NIC BROWN
ASSISTANT PROFESSOR, DEPARTMENT OF ENGLISH

On a day already filled with momentous events—both present and past—totality eclipses expectations.

IT WAS A BEAUTIFUL DAY. THE SUN WAS SHINING. A FEW THIN wisps of cloud edged through the sky. And I stood in the front yard with my head inside a cardboard box, a green bed sheet wrapped around my neck like a giant's scarf.

At first, I have to admit I was more amazed by the phenomenon of the pinhole projection inside my cardboard box than I was by the solar eclipse I was watching. I'd seen partial eclipses before. Interesting, yes. Fine. More amazing, though, was that the neighborhood was projected upside down inside my box! All because I'd poked a hole through it! Incredible. But very, very hot. So, I took off the box, glanced up at what was left of the sun through my 1950s-style sci-fi certified solar eclipse glasses, and went back inside to give my daughter presents.

Presents, yes, because August 21 is not only the day the sun hid itself behind the moon for two minutes and thirty-seven seconds. It's also my daughter's birthday. And on that day, nine years ago, my first and only child was born and—believe it or not—while my wife was in labor, I got the call offering to

publish my first two books. The day before, I'd been a childless, unpublished author with a job I hated. On August 21, though, I became the two things that now define me most: a father and an author. In this way, August 21 became a birthday of sorts for me too. What are the odds? I don't know. But low, I'm guessing.

So, an eclipse on August 21? I was waiting to be impressed. It takes a lot to make the day any more special in our house.

Presents were opened. We went outside from time to time to check on things. Progress was made. What I saw isn't news, but I'll tell you anyway. The sun kept going away. Little by little, second by second. I was interested in the properties of the light in the neighborhood. The only thing I've ever seen like that was during a wildfire in Colorado when the smoke bronzed out the sunlight for five days and I ran my windshield wipers to push away ash.

Soon the sun in Clemson had shrunk to nothing but a shimmering toenail clipping. We tossed the wadded wrapping paper onto the floor and gathered outside in the middle of our

street—my wife, my daughter, and my wife's family, in from Chapel Hill and Baltimore.

And then it went dark.

A shadow visited us. It came upon us.

My wife began screaming. My daughter started bouncing.

"Mama!" my sister-in-law yelled, using a name I've never before heard her say. "It's dark!"

"Look!" I kept saying, as if no one was. "Look! Look!"

Every newscast for weeks had told us that this exact thing would happen. There was no reason for any of us to be surprised. I didn't understand what a 360-degree sunset might look like, though. How dark it would become. That bats would fly. That the cicadas would sing—and that I would hear them singing, that I would notice, that nothing would be more obvious. That the quality of the light was neither the darkness of night nor the dim sun of wildfire smoke. It was its own special theater, never before seen by me on this planet. But none of this was why the eclipse was special. These are all just trappings around the thing itself, like looking at a trophy after triumph. I can't touch the thing itself, the magic as elusive as the orb that floats around in your vision after looking at the sun.

After what felt like only twenty seconds, an edge of our star re-emerged. An explosion. It was over? Blindsided by the realization that the moment had passed, I wanted it back. It was too short! I almost started to cry.

For the first time, I understood just how powerful the sun was. Because how could this tiny sliver—barely just a slice of it now—actually make this much difference? Yet it made all the difference, because with its return totality was gone. Totally.

I felt sorry for anyone who wasn't in the path of totality, for thinking that even ninety-nine percent coverage might look anything like what I'd just seen. It was the difference between watching someone else swim and being pushed into the deep end yourself. In frustration, I thought, I'll never be able to explain this to anyone who wasn't here. They'll just think the same thing I thought beforehand, that it was all hyperbole. I kept saying to people, "That was a thousand times better than I thought it would be. I had no idea."

When I received the news that my books were going to be published nine years ago, I understood what it foretold. That I could possibly find a way out of the nine-to-five office job I hated, where the idea of my boss' daily attacks kept me up at night in nervous terror. When my daughter arrived a few hours later, I understood that a child had now entered my life, though of course I didn't know anything about anything until she came into the world. I didn't know how she would make my life richer, remake it into more than it was. Give me a chance to understand things I didn't know I hadn't understood. That there was so much to learn about love.

Was that nine years ago? You've heard it before, but yes, time is slipping through my fingers. I don't want my daughter's

Brown watched part of the eclipse through a pinhole projection he had made in a large cardboard box. *Photo by Ryan Hoover*

childhood to disappear. But it will. The ultimate marker of that disappearance—a birthday—is just what was happening as the moon's shadow passed over us that day.

Maybe part of what was so special about the eclipse is that I can't get it back. It was so stunning, the pleasures it brought so unexpected, unknowable until I found myself within it. It reminded me of everything in the world other than me. I didn't have time to appreciate it all. I wasn't ready for it. It passed too quickly, over before I knew it. Like parenthood.

I hold the moon's shadow in my memory like I do the sound of my daughter's voice in bed later that night, as we lay on the mattress together, marveling about the movement of planets.

"I just can't stop thinking about the eclipse," she said. "I feel like someone arranged for it to be on my birthday."

"I know," I said.

"That's the best day I've ever…" She searched for the word. "Lived."

On the doorjamb in our kitchen, I've etched a rising ladder of pencil marks tracing my daughter's growth. Each line is a cicada singing, a bat flying, a 360-degree sunset. Reminders of moments passed. Planets keep spinning, though. They flip day to night. More best days will be lived.

A few days later, I purchased solar eclipse stamps at the post office. The woman behind the counter said, "Did you see it?"

"It was incredible," I said. "It was so much better than I thought."

"Me too!" she said.

I got goose bumps just standing there.

"The eclipse is my god," my wife announced, mysteriously, at dinner about a week after the eclipse. We all understood. No questions were asked.

The other day I stepped outside and found that cardboard box still lying there, neglected, beside our front steps. I put it back over my head and looked around inside it, trying to find something exciting. I wondered what the neighbors thought. A man in his yard, alone, his head inside a cardboard box. What has happened to me? The eclipse came to us for only two minutes and thirty-seven seconds, but—like my daughter's fleeting childhood, like our memories of joy—something permanent has remained.

NIC BROWN is the author of the novels *In Every Way*, *Doubles*, and *Floodmarkers*, which was selected as an Editors' Choice by the New York Times Book Review. His writing has appeared in the *New York Times*, *Garden & Gun*, and the *Harvard Review*, among many other publications. Formerly the Grisham Writer-in-Residence at the University of Mississippi, he is now an assistant professor of English at Clemson University.

Joe Mazer, director of the university's Social Media Listening Center, kept an eye on data during the eclipse. *Photo by Ken Scar*

"ECLIPSE OVER CLEMSON" ATTRACTS ENORMOUS ATTENTION ON SOCIAL MEDIA

CLINTON COLMENARES
DIRECTOR OF RESEARCH COMMUNICATIONS

The on-campus, mega-viewing party is one of the most shared events in Clemson University's history.

While one Clemson team prepared campus for an influx of 50,000 visitors for the total solar eclipse, another team was preparing to share the event around the world through social media.

"Eclipse Over Clemson" was one of the most shared events in the university's history on social media. It started with content—fifty-nine posts to Instagram, Facebook, and Twitter; seventeen videos; and more than 550 photographs.

Within twenty-four hours, these posts received:

705,695 VIEWS
of photos and videos.

240,829 ENGAGEMENTS
—people who liked, commented or shared the content.

7,261,974 IMPRESSIONS
—people reached.

29,088 SHARES

10,903 CLICKS
driven to eclipse content on Clemson.edu from our social media posts.

Sometimes, a single photograph stirs a universal spirit, an affinity for the subject, or a wonder at the composition. Sometimes, rarely, a photo provides both.

Ken Scar has captured these rare images. In 2015, he introduced the Clemson family to Lachlan the Tiger, a stuffed toy left at the very top southwest corner of Memorial Stadium, through a photo he snapped and posted on Clemson's Facebook page. The photo stirred the heart of the country, bringing attention to a family foundation that honors a little boy lost to cancer. Before coming to Clemson in 2014, Ken was shooting photos in Afghanistan as a soldier in the 1st Infantry Division. His coverage of the 2009 mass shooting at Fort Hood and the subsequent trial and conviction of the murderer resulted in his being named the 2013 Military Journalist of the Year. In 2016, his photograph "One Embrace" of a proud father hugging his newly commissioned son at an ROTC commissioning ceremony in Tillman Hall was named the Military News Photo of the Year by the US Department of Defense.

Leading up to the eclipse, Ken thought long and hard about an iconic image. Ken plotted and planned—scouting the campus for just the right vantage point in the days preceding the event. No place on campus displays Clemson's spirit writ large more than Memorial Stadium, and the perfect spot turned out to be the exact place he found Lachlan the Tiger. During the two minutes, thirty-seven seconds of totality, when the moon blocked the sun and day turned to night, Ken took this photo, "Totality over Tigertown."

Within hours, the photo was the most "liked" and shared photograph in Clemson history, with seven million impressions on Facebook and Instagram and more than 72,000 likes, comments, and shares.

TOTALITY OVER TIGERTOWN
http://bit.ly/2xjSI5P

DAY TO NIGHT TO DAY
(Our most viewed video ever on Instagram)
http://bit.ly/2hjGIrl

ECLIPSE OVER THE TIGER
http://bit.ly/2hjGVeu

COUNTDOWN TO THE ECLIPSE
http://bit.ly/2flk6GP

ECLIPSE APPROACHING
http://bit.ly/2jOK3Qe

ECLIPSE ATTENDANCE GRAPHIC
http://bit.ly/2fD6I3O

ECLIPSE ATMOSPHERE
http://bit.ly/2yg2sbk

Ken Scar took the cover photograph from the top of Memorial Stadium. *Photo by Janna Lemur*

ABOUT THE COVER PHOTO
KEN SCAR
COMMUNICATION STRATEGIST, UNIVERSITY RELATIONS

A lot of planning and hard work—and a little bit of good luck—combine to produce a photograph viewed by millions of people.

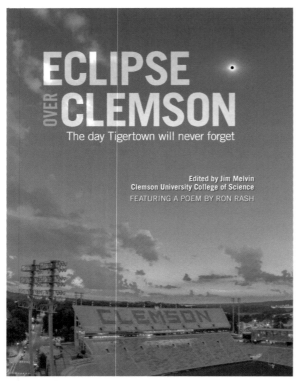

ECLIPSE OVER CLEMSON

The day Tigertown will never forget

Edited by Jim Melvin
Clemson University College of Science
FEATURING A POEM BY RON RASH

THIS PHOTO DIDN'T HAPPEN BY ACCIDENT. WHEN I FIRST HEARD about the total solar eclipse, I knew it would be ideal to get a shot of it with something identifiable as Clemson in the frame.

A couple days before the eclipse, I took a golf cart out with Clemson University social media director Robbie Fitzwater at 2:30 in the afternoon—about the time totality would occur over Clemson—and scouted locations around campus. The first thing I realized was that the sun was going to be very high in the sky, which would make it challenging to get one of our buildings in the shot. We were in the process of arranging access to the roof of the CORE Campus building, but I could tell right away that this spot would not be ideal.

Robbie and I drove around Memorial Stadium, checking out different angles and views that might work, and we finally wound up inside the stadium on the football field. From there, I could see that if I climbed to the uppermost southwest corner of the stands, I might be able to get the entire stadium and the eclipse totality in the same frame. (This also happens to be the exact place I found Lachlan the Tiger back in 2014. For more on this story, go to http://bit.ly/2wXI29Q.) But even at this elevated spot, I figured I'd have to use a wide-angle lens or a fisheye lens—and that's exactly what I wound up using.

Joe Galbraith, our director of communications for athletics, was kind enough to arrange special access to the stadium for me. My assistants and I were literally the only people in the entire stadium during the eclipse, and I think we had the best seats on Earth for it! I had about twenty minutes to break away from the Watt Family Innovation Center, where I'd been working with media and covering the scheduled events, and hustle all the way to the top of the stadium in time to catch totality. It was a hot day, so I was a sweaty mess by the time I got up there—so

much so that my camera slipped out of my hand while I was trying to attach it to my tripod and almost smashed to pieces on the concrete. Fortunately, it was attached to my shoulder by the camera strap.

I took photos with three different lenses during totality, but the one with my fisheye lens turned out the best. The sun was so high that my full-frame 24mm lens didn't even come close to getting the eclipse in the same frame with the stadium. Fisheye lenses push things out and away from the viewer, but I was able to get the entire stadium into the shot. I took several photos with the camera lying horizontally, then turned it up vertically—and that's the composition I liked the best. I knew getting the right exposure would be tricky too, so I took several pictures with different shutter speed and aperture adjustments. The money shot was taken with a shutter speed of .6 seconds, the ISO at 400, and the f stop at 5.6.

I carried a Clemson Tiger paw flag and pole up with me hoping to get some shots of the eclipse either through the flag, or next to the flag using my long 70-200 lens to compress space (making the eclipse look closer), but they didn't turn out the way I'd hoped. We had more than two-and-a-half minutes of totality, so I even had time to take a video of the 360-degree sunset, a time lapse with a GoPro, and then a few moments for myself to simply marvel at what was happening. It was a profound experience.

I spent about ten minutes taking in the scene after totality, and then gathered up all my gear and rushed straight back to my office to process the images. Robbie posted the photo to Clemson's social media pages less than an hour later. Within fifteen minutes, it had been shared by 1,600 people on Facebook and had over 5,000 "likes." We were over-the-moon at the response it received. If someone had been peeking through my office window at that time, they would have seen Robbie and I high-fiving each other. Within twelve hours, the photo was the most "liked" and shared in the history of Clemson University. As of this writing, more than eight million people have engaged with

it on our social media pages.

As a photographer who has covered a lot of events, I've often pictured an image in my head going in that just didn't wind up working. This probably happens more often than not. But sometimes, as with a total solar eclipse, things line up just right.

Scar

THE REST OF THE PHOTOGRAPHY TEAM

HANNAH HALUSKER

HEIDI HEILBRUNN

ASHLEY JONES

Hannah Halusker graduated from Clemson University in 2017 with a Bachelor of Science in genetics and a minor in biochemistry. In college, she participated in a variety of research opportunities spanning the fields of genetics, biochemistry, and primatology, studying organisms such as corn, the parasite Trypanosoma brucei, and a small New World monkey called a golden lion tamarin. Halusker's role as a public information coordinator for the College of Science has her writing and taking photographs every day about the vast range of scientific research happening at Clemson University.

Heidi Heilbrunn is an award-winning freelance photojournalist. Her images have been featured in national and international publications. She began her career working for daily newspapers in South Carolina, where she passionately covered breaking news, health, the arts, and sports. Formerly a staff photographer and videographer for the *Greenville News* and the USA Today Network, she left in 2016 to pursue a freelance career. She is currently based in Georgia and works throughout the Southeastern United States.

Ashley Jones brings an eye for detail and a fresh take on old campus sites in her job as one of Clemson's photographers. A Clemson Tiger by birth, even if not by degree, she's a graduate of Lander University with a degree in visual arts. She has been working as a wedding and portrait photographer since earning her degree in 2005, and has been with Clemson's Department of University Relations since 2014. Jones earned accolades for her work from the University and College Designers Association (UCDA). When she's not working, you can find her with her husband Mike (Clemson '03) and daughter Savana, hiking, cooking, and creating artwork of all kinds.

CRAIG MAHAFFEY

Craig Mahaffey captures the stories of Clemson through his photography. A 1998 graduate, he taught high school for three years before finding his calling behind a camera lens. Mahaffey has worked in the Department of University Relations since 2006. He also runs a wedding photography business, Sposa Bella Photography, with his wife Lindsey. In 2011, he was named the South Carolina Wedding Photographer of the Year. In their spare time, he and Lindsey enjoy traveling around the globe, sampling local cuisine and experiencing local culture.

PETE MARTIN

Pete Martin is the online media coordinator for the College of Science. An avid photographer since high school, he enjoys shooting weddings, seniors, and commercial headshots. His work has been published in print and online in the *Greenville News, TALK Greenville* magazine, *Upstate Parent* magazine, and other publications in the USA Today Network.

PATRICK WRIGHT

Patrick Wright was born in California and raised in South Carolina. He graduated from Chowan College in Murfreesboro, North Carolina. From 1979–88, Wright worked as a photographer at the *Anderson Independent-Mail*. He has been at Clemson University as a photographer since 1988, and plans to retire in June 2018.

THE COLLEGE OF SCIENCE WISHES TO THANK THE FOLLOWING PEOPLE FOR THEIR ROLES IN HELPING TO ORGANIZE OUR "ECLIPSE OVER CLEMSON" TOTAL SOLAR ECLIPSE VIEWING PARTY ON AUGUST 21, 2017.

Christie Ackerman
Máté Ádámkovics
Cade Adams
Bo Akinkuotu
Alexandria Alabau
Mark Albertson
Louie Alexander
Teri Alexander
Desmond Allen
Jon Allen
Paul Alongi
Denise Amos
Imani Anderson
Kendall Anderson
Sarah Arbogast
Lucy Arthur
Tracy Arwood
Josh Ashley
George Askew
Rebecca Atkinson
Kelly Lynn Ator
Angie Aubert
Mary Baghdady
Scott Baier
Henry Baird
Jenna Marie Baker
Phillip Baker
Cassidy Baldwin
Rob Baldwin
Catherine Balsitis
Jacob Barker
Todd Barnette
Barbara Bass
Sarah Baum
Kendall Bedard
Mac Bevill
Meg Bishop
Star Black
Jessica Blackwell
Laura Blakely
Rick Boulanger
Jan Bright
Jeff Bright
Sean Brittain
Chantoya Brown
Jeffrey Brown
Nic Brown
Ricky Brown
Tim Brown
Devin Broyles
Caleb Bruce
Sharetta Buford
Matt Bundrick
Joquita Burka
Emily Burns
Tullen Burns
Dan Byers
Megan Byham
Jada Byrd
Erik Cartledge
Katherine Castillo
Michele Cauley
Job Chen
Irene Cheng
Jonathan Chiu
Aleysha Clark
George Clay
Jim Clements
Natalie Cliver
Dale Cochran
Asha Collier
Clinton Colmenares
Courtney Conger
Dakota Cook
J.C. Cooke
Victoria Corbin
Carrie Cottingham
Tammy Crane
Harriett Graham Courtney
Courtney Cowan
William Daniel
Jeannie Davis
Pam Davis

David Day
Jack Debbout
Taylor DeHart
Robin Denny
Dial Devaney
Anthony Dickson
James Dillard
Tyler Dindinger
Jimmy Dixon
Marvin Dixon
Dennis Driscoll
Dave Dryden
Shatari Dunmore
Darlene Edewaard
Katie A. Elliott
Garrett Ellward
Rick Ertzberger
Dallas Erwin
Donald Eubanks
Stephanie Evans
Leasa Evinger
Ashleigh Ewens
Tommy Fallaw
Brad Farrell
Maggie Farrell
Dwayne Fennell
Josue Figueroa
Lynn Fisher
Robbie Fitzwater
David Fleming
Butch Fortner
Daniel Foster
Jonathan Free
Gloria Freeman
Katherine Freeman
Dave Frock
Haley Fulton
Tessa Gagne
Joe Galbraith
Debra Galloway
Victoria Galway
Quameshia Gantt
Stella Garber
Andrew Garmon
David Garrett
Jillian Gaskins
Yoel Gebrai
Kelly Geiger
Mark Gilbert
Jesse Godfrey
Denise Godwin
Destyni Golatt
Rick Goodstein
Patrick Gorospe
John Gouch
Anand Gramopadhye
Billy Grant
Ron Grant
Joey Greene
Sean Greiner
Rick Griebno
John D. Griffin
Guadalupe Hackett
Cooper Hall
Doug Hallenbeck
Hannah Halusker
Derrek Ham
Rachel Hannah
Alexander Hartmann
Dieter Hartmann
Aynsley Hartney
Lauryn Harriford
Karen Hawkins
Mandy Hays
Kenneth Hellams
Ashleigh Helms
Sloane Henningsen
Daniel Hernandez
Lois Heyward
Leonard Hightower
Brooke Hisrich
Lindsay Hobbs
Kathy Hobgood

Daniel Hofmann
Mackenzie Hohman
Beth Holland
Sara Hopkins
Tim Howard
Dan Huisenga
Christine Humowitz
Adam Hunter
Mackinley Hunter
Matthew Hunter
Timothy Hurlburt
Angel Jackson
Lee James
Marie Jarrell
Evonna Jenkins
Mark Jensen
Shane John
Breanna Johnson
Camden Johnson
Hannah Johnson
Wanda Johnson-Stokes
Phillip Johnston
Ashley Jones
Bob Jones
Tom Jones
Bianca Jordan
Joni Deanne Jordan
Cara Joseph
Gail Julian
Adam Justice
Mary Von Kaenel
Jessie Katz
Abigail Keating
Tracy Kelly
Melanie Kieve
Jeremy King
Jason Kinley
Nicole Koenig
Isabel Korn
Keerti Kosana
Bill Kramer
Taylor Laible
Mark David Land
Melody Land
Drew Lanham
Colby Lanhem
Allie Larson
Greg Lawrence
Jason Lazar
Mark Leising
Dallas Lenderman
Victor Liao
Donald Liebenberg
Karl Liebenberg
Norma Liebenberg
Chelky Lin
Johnson Link
Jordan Little
Hailey Lovelace
Samantha Lovern
Mary Lyons
Michi Macias
Dante Magagnotti
Craig Mahaffey
Lee Maiden
Sindasha Makins
Todd Marek
Keith Martin
Pete Martin
Walker Massey
Tim Match
Erin Mayor
Joseph Mazer
Bob McAnally
Susan Erwin McCall
Mitch McCarter
Shelly McComb
Bobby McCormick
Sandra McCurry
April McDaniel
Nathan McDowell
Katie Barnes McElveen
DeAnna Michelle McEntire

Myles McKenna
Will McLaughlin
Emily McMacken
Patrick McMillan
Mike Melton
Jim Melvin
Thomas Messervy
Chris Miller
Leland Glenn Miller
Paul Minerva
Gordon Mitchell
Haley Mitchell
Mike Money
Mike Moore
Mollie Moran
Katerina Moreland
John Morgan
Rhyan Morgan
Mary Erin Morrissey
Scott Moss
Hansen Mou
Betsy Mudge
Daniel Mulqueen
Lizza Muszynski
Sharon Nagy
Madeline Nance
Michael Nebesky
Tim Nix
Angela Nixon
Joshua Norman
Jason Osborne
Jessica Owens
Margaret Owens
Michael Owens
Herb Parham
Blake Parker
Frances Parrish
Joe Parrish
Lanz Pasig
Steven Pate
Manushi Patel
Mayank Patel
Radha Patel
Brian Patterson
Jane Patterson
George Petersen
Ed Poland
Surabhi Poola
Amber Porter
Lauren Prox
Kevin Pruitt
Cindy Pury
Tony Putnam
Ben Quarles
Henry Randall
Amy Lawton-Rauh
Brad Rauh
Brooke Redmond
Sarah Reeves
Susan Reeves
Micki Reid
Tommy Reid
David G. Reynolds
Linda Rice
Tara Richbourg
Zach Roach
Janette Robbins
Candace Robinson
Tia Robinson
Tony Rochester
Eric Rodgers
Katie Rogers
Natalie Rogers
Tara Romanella
Raymond Rude
Katherine Russ
Paul Ruszkowski
Mitch Ryals
Jameson Sanders
Nick Santagelo
Aimee Sayster
Ken Scar
Christianna Schmidt

Mike Schrader
Bob Schuster
Nicholas Seiter
Shreya Shankar
Jennifer Shealy
Rise Sheriff
Ricki Shine
Phillip Siegel
Philip Sikes
Solomon Goodwin-Simmons
Theresa Singletary
Lauren Singleton
Brenda Smith
Dena Smith
George Smith
Karenna Smith
Kelly Smith
Michael Smith
Roy Smith
Scott Smith
Arya Soman
Christian Sommerville
Chad Sosolik
Glenn Spake
Mark Spede
Barbara Speziale
Stephen Spiller
Nancy Spitler
Daniel Springs
Thomas Standridge
Ty Standridge
Daniel Stanley
Tiffani-Shae Starks
Michael Staton
Blythe Steelman
Brittany Stephenson
Peter Sterckx
Samantha Studer
Michael Summers
Stewart Summers
Jumah Taweh
Sagar Thakur
Sam Thavarajah
Ambria Thomas
Linda Thomas
Hanna Tobin
Jackie Todd
Rhonda Todd
Terry Tritt
Juliana-Marie Troyan
Katelyn Truong
Rick Uhlmann
Jonathan Veit
Kumar Venayagamoorth
Andrea Vera
Logan Wade
Sam Walker
Erica Walters
Helena Walters
Randy Ward
Tim Wayman
Weatherly Webb
Vanessa Weston
Gabriella Wheeler
Timothy Whims
Maggi Whiston
Tina White
Angelica Williams
Heidi Williams
Mariah Williams
Angelica Wilson
Tyreek Wilson
Victoria Wilson
Renelyn Wolters
Waco Woods
Jacob Wortkoetter
Brett Wright
Debbie Wright
Pat Wright
Cynthia Young
Tiffany Yu
Flourish Events

CPSIA information can be obtained at www.ICGtesting.com
Printed in the USA
LVIW01n0600281217
561067LV00034B/579